THE TALLAHASSEE PROJECT

ONE HUNDRED PRISONERS OF THE WAR ON DRUGS

A PROJECT OF THE COMMITTEE ON UNJUST SENTENCING

LAST GASP OF SAN FRANCISCO

Published and Distributed by

Last Gasp of San Francisco,
777 Florida Street
San Francisco, CA 94110
www.lastgasp.com

Copyright © 2001 by The Committee on Unjust Sentencing

The Committee on Unjust Sentencing
P.O. Box 76665
Los Angeles, CA 90076
www.drugwarprisoners.org

Book design by Ron Turner and Charles Brownstein
Layout by Charles Brownstein

ISBN 0-86719-514-2
First Last Gasp Edition, April 2001
00 01 02 03 4 3 2 1
Printed in Hong Kong by Prolong Ltd.

TABLE OF CONTENTS

To the 100 women POWs in FCI Tallahassee whose words grace these pages, this book is dedicated,

To all 400 women POWs in FCI Tallahassee, companions in sorrow, this book is dedicated,

To 30,000[1] women POWs in prisons across America, taken by agents of the War on Drugs, this book is dedicated,

To 500,000[2] men and women POWs, condemned for being on the wrong side of the War on Drugs, this book is dedicated,

To 2,000,000[3] former POWs under the control of probation officers and others "doing their job" in the War on Drugs, this book is dedicated,

To 5,000,000[4] family members and friends of current POWs, separated by the War on Drugs, this book is dedicated,

To 20,000,000[4] former POWs and their friends and family members, lives variously ruined by the War on Drugs, this book is dedicated,

To those more than 25,000,000 past and present POWs, their friends, and their family members, one tenth of the US population, this book is dedicated,

To the nine tenths of the US population who pursue or let others pursue the War on Drugs, this book is also dedicated. May its pages show the error of their ways.

[1] 1996 figures + 10 percent

[2] a conservative estimate

[3] based on assumption that for each imprisoned POW, 3-4 others are under the jurisdiction of the courts in various capacities

[4] based on assumption that each POW has left behind 10 friends and family members

PREFACE

Any sensible person will agree there is a place for government in the production, use, and distribution of drugs which, though illegal, enjoy widespread use among Americans. Standards relating to purity and so forth can be enforced, in conjunction with private enterprise, without intruding on the right of citizens to pursue the kind of life they deem worth living, given that the interests of others are not harmed. Government regulation of the production and trade in drugs that today millions of Americans use in violation of the law would benefit society. Regulation would remove the worst features of the policy in force today, known as the War on Drugs but actually a war on people who use illegal drugs or have a connection with people who use them. One hoped-for result of the publication of this book is that it will call attention to the desirability of phasing out the War on Drugs and adopting a policy of regulation in its place.

Criticism of US policy in the field of illegal drugs centers on three main objections: the policy is irrational, it is contrary to the best interests of society, and it is demonstrably futile. Prosecution of a War on Drugs is irrational because it advances towards an ever-receding goal, the establishment of a "drug-free America" and a "drug-free world." No world occupied by humans has ever been drug-free, or will be. Pursuit of a goal that is unreachable by definition implies a war that will drag on indefinitely, victory in sight but never won. Blind to the reality of a war that no matter what effort is put into it cannot be won, Drug War policy wonks are guilty of irrational behavior of a far-reaching kind.

Incarcerating people who use illegal drugs and isolating them from society is the cornerstone of Drug War policy. The policy runs counter to the best interests of society because it fosters the illusion that the cost of imprisoning large numbers of people for behavior that is not inherently immoral can be safely overlooked. It cannot. Today in the United States 500,000 people wake up each day in prison for the use of some illegal drug – often not even use, for mere association with someone who uses an illegal drug can bring imprisonment for 20 years or life, as *The Tallahassee Project* eloquently attests to. Destruction of the life of each Drug War prisoner dooms the lives of separated family members, children, spouses, and others left behind. Add to this the untold number of former Drug War prisoners and the members of *their* families who bear the taint of a felony conviction and the penalties that brings. The total is incalculable but certainly amounts to millions. Consider the collective hatred, anger, alienation, despair and related pathologies rooted in so many individuals, and it is clear that the society to which these individuals belong will pay for the Drug War folly and pay dearly. It is no exaggeration that the War on Drugs does more harm to society than drugs themselves.

The third objection critics raise is that the War on Drugs has not brought an iota of success. Define success as reduction of the rate of illegal drug use over the period that the War on Drugs has been in operation. Define the onset of the War on Drugs as the day President Nixon took office in 1968 – a convenient landmark. What critics assert as irrefutable is that the rate of illegal drug use is the same today as 30 years ago. A business practice with this sorry record would have long since been dropped and those responsible for it fired. The futility of the Drug War, measured in terms of the consumption of illegal drugs, should be enough to force its termination. The familiar complaint that Drug War policy has "failed" reflects a provable statistic.

The three-day period of June 6-8, 1998 was the occasion of a debate at the General Assembly of the United Nations in New York on the "world-wide threat of drugs." Timed to mark the anniversary of the signing of a UN convention on illegal drugs, the debate was hailed as an opportunity for representatives of member nations to discuss problems associated with illegal drugs and consider new approaches to deal

with them. Some time in January of that year, news began to filter through to critics of hard-line US policy that the agenda of the UN debate had been changed to meet the wishes of the US government. To the consternation of those in the know, the refashioned agenda would permit no deviation from the US position. There would be no challenge to the US-led War on Drugs by members of the international community.

At the same time, word surfaced of a demo planned for the weekend before the UN debate to protest the gag placed on the General Assembly's deliberations. A group of Drug War critics in the Mid-West proposed a march up First Avenue to the United Nations Plaza, followed by a rally where speakers would publicize the censorship about to take place across the street. It seemed a golden opportunity for someone like myself to speak out on behalf of America's Drug War prisoners, if not prisoners of the War on Drugs worldwide. The thought then occurred that a Drug War prisoner presence would heighten the impact of the demo. Obviously, none of the current half-million Drug War prisoners in the US would attend, and few if any ex-Drug War prisoners would be prepared to air their grief in public. What later became known as the Tallahassee Project grew out of the search for an answer to the question: how to introduce a Drug War prisoner presence into the rally set for June in New York City.

Suppose a collection of statements by Drug War prisoners themselves, exposing the nature of a justice system that inflicts sentences beyond the scope of most people's imagination – suppose a volume of such statements accompanied by photographs was presented to the Secretary-General of the United Nations. The concept of an appeal by Drug War prisoners to the head of the United Nations, highlighting a rally in defense of common sense and justice, struck a spark that once lit refused to go out. Time to compile the volume, however, was short. A bare four months remained before the rally would take place.

The one person I knew with the strength and integrity to undertake such a project was Karen Hoffman. Karen, an LSD prisoner incarcerated in the prison known as FCI Tallahassee, was someone I corresponded with in the course of working with The Committee on Unjust Sentencing, a Drug War prisoner advocacy group with supporters in North America and Europe. I wrote to Karen to ask if she would like to convey the idea of a POW appeal to the UN Secretary-General to her fellow-Drug War prisoners in Tallahassee. (Karen, like many prisoners of the War on Drugs, considers herself a prisoner-of-war, and the reader may bear with me if I do the same.) Karen took up the idea, and I was soon hearing of forms being passed around and photographs being taken for the project. For the record, use of the term "Tallahassee project" became current at this time. Tallahassee's POWs used it to refer to the work they were undertaking.

Becky Stewart deserves equal credit for the compilation of this work. Becky was also on the list of POWs I corresponded with. Maria Herrera was the third member of the team that circulated forms and advised women Drug War prisoners in FCI Tallahassee of the opportunity to send a message to the head of the United Nations. The credit for bringing this work to a conclusion belongs exclusively to these three women.

After January, weeks went by, with statements and photographs starting to arrive at the Committee's address in Los Angeles, but with a dearth of information on plans for the demo in New York. By April, it was obvious that something was wrong. In May, the word came that the plan to stage a demo outside the United Nations had been cancelled. Instead, a smaller, more manageable event was in the works. In place of a march up First Avenue and a rally in the vicinity of the UN, the proposal was for teach-ins and press conferences on Drug War policy at some distance from the UN, spread over the three days of the debate, with daily flower-laying ceremonies in honor of those imprisoned.

In the end, the proposal for an event on even a reduced scale fizzled out. What looked like a failure of nerve dealt a double blow. By the end of May I had in my possession about 70 statements from the women of FCI Tallahassee, accompanied by photographs. The material was mounted in an album, ready for shipping to New York where an acquaintance had agreed to show it at the teach-ins – with nowhere for it now to go. In Tallahassee, meanwhile, interest in the New York event had reached crescendo pitch. Confessing failure to deliver on a project that had flopped, I wrote to Karen, and through her to Becky and Maria, for advice on what to do. At this moment of crisis, I was grateful to the women of Tallahassee for not calling it quits. The reply that came back was to hold on to the material and do with it as I saw fit.

With thoughts of getting the document into the hands of the Secretary-General in abeyance, and with the UN debate allowed to proceed without a serious challenge, the next best thing was to secure publication of a volume to be called *The Tallahassee Project*, if possible in facsimile.

The reader may ask what happened to the *Project* between May, 1998, when plans for the UN demo collapsed, and November, 1999, when Last Gasp of San Francisco took publication of *The Tallahassee Project* under its wing. What happened is that the women of Tallahassee took the work to a new level of comprehensiveness. Women now joined the enterprise who for one reason or another were left out the first time around. Accepting that the purpose now was not to present a document to the Secretary-General, but to publish a book for the reading public, new contributors expressed their thoughts, and with the extra time available could do so at greater length. The advantage provided by this added material is that the meaning of "conspiracy," "informant," "set-up," and so forth, part of everyday reality for Drug War prisoners but scarcely known outside the Drug War prisoner community, are fleshed out in convincing detail. The longer statements complement the brevity of not all but many of the responses received before June, 1998, making this work a true reflection of the tragedy America must somehow face.

Included in these pages is a copy of the form that Karen and Becky passed out to their fellow Drug War prisoners, requesting name, registration number, age, length of sentence, charge convicted of, and any statement a woman might want to make. Examples of such forms filled out with the requested information are reproduced here in facsimile.

To distinguish entries intended for the Secretary-General (the "you" the original contributors addressed) from the generally more comprehensive entries received after May, 1998, an asterisk has been placed beside the names of the "latecomers," in the index of names preceding the main body of the text.

Editorial interference has been kept to a minimum. Statements have been rendered word for word, grammar and spelling on principle kept intact and only "corrected" when a slip was obviously not the writer's practice. The charge for which convicted and the length of sentence – in years or months – have been recorded as the prisoner's hand dictated. The other exception to a hands-off policy is where an entry was overly repetitious or had to be shortened for some other reason.

So much for how The Tallahassee Project came about.

John Beresford, M.D.
The Committee on Unjust Sentencing
P.O. Box 76665
Los Angeles, California 90076

INTRODUCTION

All of the women in this book are non-violent drug offenders; many are first-time offenders. The lengthy sentences they have received are real; they will serve the majority of their time incarcerated, as parole no longer exists in the federal system. Some of these women have LIFE sentences, which means they will spend the rest of their natural life in prison.

In 1970, the United States embarked on a program entitled the Comprehensive Drug Abuse Control Act of 1970, which regulated the possession, distribution, or diversion of "controlled substances." Prior to drug prohibition, there were fewer victimless crimes on the books. There were fewer penalties for victimless crimes ("malum prohibitum"), compared to penalties for victimizing crimes ("malum in se"). Today, many people complain of the double standard applied to the use of traditional European drugs like alcohol and tobacco and the use of non-traditional drugs like marijuana, peyote, cocaine, and opium. New laws attach a puritan morality to non-traditional drug use. As a result, drug penalties bear no reasonable relation to offenses against legitimate government or societal interest. Violations of the Controlled Substance Act carry disproportionately severe penalties.

The War on Drugs has created a counter-revolution in personal freedom. The martial-law aspect of the War on Drugs has done great harm to what were constitutionally protected liberties. Police in search of drugs come as invading armies in African-American, Hispanic, and poor communities. No longer does an individual feel secure in his or her own home or vehicle or person. Mere suspicion is grounds for an invasion of privacy. Once, our top priority was to be a "Free Country," not a "Drug-Free Country." No reasonably free society has ever incarcerated more of its citizens than has the present United States. The War on Drugs has turned a significant number of our citizens into criminals, with tens of millions of arrests for non-violent offenses on the books.

The Sentencing Reform Act of 1984 established the United States Sentencing Commission as an independent agency in the judicial branch. The purpose of setting up the Commission was to "get tough on crime." The Commission would abolish the Parole Board, which granted extra good time for good behavior and evidence of rehabilitation while incarcerated. The Commission's first set of Guidelines were submitted to Congress in April, 1987, and went into effect in November of that year. Henceforth, convicted defendants would routinely serve 85 per cent of their time in prison.

The Federal Sentencing Guidelines drawn up by the Commission established a point system which assigns a base offense level according to drug quantity. The base offense level translates into a sentence. Consideration of human factors by judges was abolished. Judges no longer have the right to exercise discretion in accordance with the circumstances of a case. Offenders are sentenced strictly in accordance with the quantity of a drug attributed to a defendant, or, in the frequent case of a "conspiracy," the quantity attributed to a co-defendant.

In 1986, Congress introduced mandatory minimum sentencing for drug offenses, distorting the guidelines drawn up by the Commission. A mandatory minimum sentence is calculated by the prosecuting attorney, who frames the charge for which a defendant is prosecuted and hence the penalty imposed upon a finding of guilt. In practice, a mandatory minimum sentence falls most often on the "little guy." The only means of escaping a mandatory minimum sentence is for the defendant to provide the prosecutor with "substantial assistance," or information that incriminates another – and typically the little guy has no

incriminating information to offer. Mandatory minimum sentencing law causes lengthy sentences to be imposed on petty dealers and drug users, when the Guidelines alone would call for shorter sentences. Supreme Court Chief Justice William Rehnquist called this "a good example of the law of unintended consequences."

Many women who participated in *The Tallahassee Project* feel the force of this cruel practice.

Harsh sentences imposed on non-violent drug offenders would be more suited to violent, antisocial criminals. Yet the federal government is exceedingly nonchalant towards violent offenders. In a federal court, a child molestation case carries a mandatory minimum sentence of 24 months. Voluntary manslaughter bears a maximum of ten years incarceration, which is the lowest conceivable sentence the average first-time non-violent drug offender can hope for. Such paradoxical sentencing reflects the travesty of justice that our justice system has become.

Today's United States may be compared with the negative utopia of Orwell's "1984." The charge of "conspiracy" in the prosecution of so many drug offenders corresponds to Orwell's "thought crime." Our Drug Enforcement Agency corresponds to Orwell's "thought police." The pages of this book show the use made of "conspiracy" to swell the population of Drug War prisoners. Many of the women sentenced for drug offenses in FCI Tallahassee have been convicted without tangible evidence of illicit substances, money, tapes, fingerprints, or anything real and solid. Drug convictions frequently are based on "hearsay" evidence alone.

Worse, prosecution witnesses, themselves under indictment for some drug offense, are offered money or substantially reduced sentences for fabricated testimony. It is not uncommon for a potential witness to be coached by a prosecutor to ensure that testimony conforms to what the prosecutor wants. Fear of inevitable loss at trial – drug defendants virtually never win – and the life-crushing sentence that follows conviction pushes many an innocent defendant to plead guilty and accept a lesser punishment.

A major factor in determining who the government will pursue for drugs is money. While there are no funds to be harvested from prosecuting violent crimes, forfeiture law authorizes the government to seize money, vehicles, homes, and other assets from anyone remotely connected with a drug case. Proceeds from confiscated items generate a kickback for the government and local police departments. Not surprisingly, the government devotes more resources to the pursuit of drug cases, while heinous crimes remain unsolved.

UNICOR is the brains of the Bureau of Prisons, the agency that runs the federal prison system. UNICOR factories throughout the federal system generate over 500 million dollars a year in revenue. Salaries and working conditions in UNICOR factories are comparable with those in Third World country sweatshops. FCI Tallahassee has two such factories. One produces furniture, the other logs patents for the United States Patent Company. The furniture factory here averages one million dollars a month in revenue. The patent department exceeds that amount. A woman working in the patent department in the outside world would receive $30 an hour for her labor; the UNICOR base wage is 22 cents an hour. The expense of being incarcerated for us prisoners – we pay for

hygiene needs, stamps, medicines and much else – forces many to work for UNICOR, especially those with children we endeavor to support.

Although UNICOR pays its employees little, it still manages to charge on average 13 per cent more than private companies. The Federal Prison Industry is guaranteed a flow of customers, nevertheless. Federal government agencies are required to meet their purchasing needs through the FPI's 32 regional sales representatives. They must deal with the FPI, whether or not the same or better quality products are obtainable for less in the "free world" market.

Plans are under way to open more UNICOR factories across the country. Mandatory minimum sentences ensure that the factories will have workers. No one with a short prison sentence is permitted to work for UNICOR. Mandatory minimum sentencing of drug offenders enables the FPI to guarantee their ability to keep long-term agreements, undercutting the free world businessman who must deal with a fluctuating economy.

The Anti-Terrorism Effective Death Penalty Act (AEDPA), containing the Habeas Reform Act and signed by President Clinton in 1996, severely restricts access to the courts by federal prisoners. Habeas Corpus – the "Great Writ" – has for three centuries provided a means of securing relief for prisoners whose constitutional rights have been violated. Before passage of the AEDPA, habeas corpus action could be initiated at any time by a prisoner. Now, time for filing ends one year from the date a sentence becomes final. Many prisoners, illiterate and unversed in law, are unable to meet this deadline. Before they can begin to understand the law they must first learn to read and write. Prisoners taken in the War on Drugs who want their cases reviewed must meet the one-year deadline, or serve lengthy sentences with no hope of deliverance.

With the enactment of our country's drug laws, prisons are bursting at the seams. Entire families are being swept into the tomb of the prison system. More than 60 per cent of federal prisoners are non-violent drug offenders, as are at least one third of prisoners nation-wide. The number of drug prisoners hovers around half a million.

Here at FCI Tallahassee overcrowding is a fact of life. The prison was inaugurated to house 487 prisoners. We are currently 110 per cent over capacity, more than double. The new bunking system (four women to a cubicle) allows the Bureau of Prisons to warehouse prisoners with no consideration for privacy, sanitation, or safety. Plans are under way to construct more such living arrangements, allowing each woman a mere six square tiles of living space. There are laws that protect animals from such treatment.

Most Bureau of Prisons staff at FCI Tallahassee are army cast-offs. Staff are trained to not see us as persons. We are not human beings in their eyes but inanimate objects. They despise us and make no bones about it. Prison officials tyrannize and degrade us when they can. Strip searches do not function as a security measure but as a form of humiliation. There is no security function in the repeated inspection of a woman's anus. The Bureau's rule is to dehumanize wherever possible.

In July of 1998, shortly after the meeting of the United Nations General Assembly for which this work was first prepared, many of the women you will see here united in opposition to unbearable conditions and waged a "food strike." Daily oppression drove us to the brink. At first, staff response was to tempt us

with a steak dinner. Finding this ineffective, staff went berserk, seizing prisoners at random. Women, whether they had participated in the "food strike" or not, were dragged out of bed or the shower and taken out in pouring rain to a waiting bus. They were shipped to a detention center to await transfer to prisons across the country, chained and shackled. Some of the women you are about to meet are now dispersed in prisons in all parts of the United States.

The women you will encounter in the pages of this work come from different social, cultural, and economic backgrounds. For us, compiling *The Tallahassee Project* has been an unprecedented act of public relations in the face of extreme injustice. Fear of retaliation by the Bureau has been the greatest obstacle to overcome. Nevertheless, here we are, waiting to let you in on America's dirty secret. The statements presented here are unchanged from the day they were recorded. Reader, we ask that you read these pages with respect. Think of us as human beings like you, not just a pile of names and prison numbers.

<div style="text-align:right">

Becky Stewart
Karen Hoffman
The Tallahassee Project
Federal Correctional Institute,
Tallahassee, Florida
June, 1999

</div>

INDEX OF NAMES

NAME	Federal Registration Number	Sentence (Years-Months)
Lakethya Abdullah	21184-018	23-0
Doris Admon	04106-041	20-0
Irma Alred*	03436-017	30-10
Mary L. Ames*	21692-018	3-9
Janette Andreu*	19578-018	7-0
Stacey Lynn Arena	26804-083	17-6
Martha Ayala	33303-004	13-0
Esperanza Rodriguez Arevolo	46354-004	12-7
Joyce Ann Barringer	11546-058	8-11
Marilyn Bello*	10230-112	24-4
Sonia Berrios	35694-004	24-0
Rosalyn Blackmon	14890-074	15-0
Sonja Brockman	14665-047	10-10
Jacqueline J. Brown	10332-017	14-0
Theresa Brown	47478-004	LIFE
Carla Buggs	19083-001	27-0
Denese Calixte	51291-004	10-0
Elizabeth Chapa*	16145-074	27-0
Debroah Chisholm	09967-058	14-0
De-Ann Coffman	23046-077	85-0
Pamela O'Hara Cooper*	08087-021	40-0
Katie Mae Core	07961-021	12-0
Rosa Cruz	33346-004	14-10
Marsha Cunningham	30862-077	15-0
Martha De Diaz	50830-053	4-9
Frankie Delise	40043-037	25-0
Diane DeMar	41010-019	LIFE + 5
Sharron Dueitt-Jackson*	02854-003	5-0
Sylvia Elang	40730-004	8-10
Maria Ellis	61998-079	15-8
Joyce Enos	15362-018	15-8
Lois Dell Fait*	18530-018	11-3
Ada Fernandez	34698-004	10-1
Saira Florez	30579-004	15-8
Bambi Dawn Gammell	13515-064	5-0
Deborah Gardner	45268-019	10-1
Jackie Gates	07467-041	5-0
Stephanie George	04023-017	LIFE
Luz Giraldo	09512-069	14-0
Carmen Eliza Gomez*	52937-004	9-0
Carmen R. Gomez	51950-004	4-9
Ivonne Gonzalez*	45995-004	11-3
Alva Groves	15230-056	25-0
Wanda Growther	05375-030	8-0
Socorro Guerra	19220-004	35-0
Rosalba Gutierrez	14390-018	24-4
Patricia Ann Harris	21594-018	10-10
Robynne Hayes	03474-030	11-4
Maria Herrera	37254-004	10-0
Karen Hoffman	00644-049	10-0

NAME	Federal Registration Number	Sentence (Years-Months)
Ethel Jackson	12768-018	23-0
Gardenia Jackson	47633-004	19-6
Yvette James	05152-032	5-10
Crishone C. Johnson	05809-084	20-0
Alice Jones	29560-004	24-0
Beverly Joseph	05198-078	20-0
Lorilee Leckness	03778-030	17-0
Mariella Liggio	35197-004	22-0
Patricia Locklear	15627-056	24-4
Veronika Londrano	40770-004	11-0
Diana Lopez-Mesa	11992-018	12-0
Melva Lozano	46764-004	20-0
Alfreda Evette Luxama	09076-018	5-0
Mary Elizabeth McBride	09801-042	LIFE
Judy McCarroll	08864-424	27-0
Louella McCormick	15360-018	17-6
Tonya L. McNeil	16831-054	12-0
Amparo Romillo Medina	24537-004	17-6
Elainaise Mervil	20982-018	20-0
Monica Monsalve	44419-004	3-10
Patricia Moore	82960-020	24-4
Reyna Morales	04811-112	20-0
Charlene Morgan*	28731-004	10-0
Andrea R. Myers	91921-071	21-10
Bessie Oliver	03321-025	LIFE
Brenda Owens	22617-077	20-0
Edith Morales Padilla	44080-004	8-1
Evelyn Bozon Pappa	48576-004	LIFE
Patrina Parker	15275-057	19-7
Ruth A. Peabody	03440-036	5-6
Cloretha Peak	18114-018	LIFE + 25
Sonia Estrada Peinado	44449-004	3-10
Glenda Marie Porter	10646-058	14-0
Rosa Pulido	09373-018	14-0
Wenseslada Reyes*	18627-077	21-0
Linda R. Rojas	79002-079	10-1
Diane Smith	03442-017	15-0
Becky Stewart	34290-080	18-0
Eva St. Germain	10122-058	6-0
Billie Marie Taylor*	03453-078	34-6
Carolyn Taylor	18654-057	11-3
Veronika Tillman	39683-004	10-0
Brenda Valencia	39589-004	12-7
Maria Victoria Velez	03112-112	7-3
Sheryl L. Waters	11171-058	23-6
Diana Webb*	99871-011	12-6
Jo Ann Winter	29397-077	23-0
Shirley Tucker Womble	09330-017	25-0
Margaret Woodard	15231-056	30-0
Pamela Woodard	15229-056	17-6

* = entry received after May, 1998

THE TALLAHASSEE PROJECT:
ONE HUNDRED PRISONERS OF THE WAR ON DRUGS

THE TALLAHASSEE PROJECT

Lakethya Abdullah 21184-018 Age 23
20 years Possession of Cocaine

I'm currently in 11th Circuit of Appeals. (Where the odds are very low.) I'm a resident of Tampa, Florida. One prior possession 16 grams. Not a convicted felon, and withheld adjudication on my priors. But I was tried as a convicted felon. I lose my trial. But I have good ground for my appeal.

What I see concerns my judge Susan Bucklow. Statement she made: If 8 of yall fill she's guilty then maybe the rest of yall need to take in consideration (then the other way around), which I fill the jury was force into decision because they put that they couldn't come up with a verdict, not today not tomorrow or whenever. She stressed that they new the case and that picking another jury was a waste of time and money. Which I felt the concerns of money and time was not the concerns there in that court room my life was.

My feelings: Prejudice towards me, not allowing the jurors to do there job as jurors of decision. I thought the case was looken personal and not professional. And am asking for help.

Please.
Thank You
Lakethya Abdullah

Doris Admon 04106-041
Age 49 20 years
Count 32: Conspiracy to Possess/
Distribute cocaine, 21 USC 841 (a) (1)

Count 24: Travel in Interstate Commerce
to Distribute Proceeds of Unlawful Activity,
18 USC 1952 (a)

I feel like Congress is really unjustice in this matter of (Drug War). Giving us all this time will not the problem in USA. Common since, they would know how to solve the (Drug War). Hit the Big people with planes, ships, etc. Undercover work. Deep in my heart the Government has a great part with this matter, hands in the fire too.

Stop this matter, and put things back to priority. Young men and women in prison. Baby's in the street turning into self-desturction. We must put a stop to this matter, or we will not have a new postive upcoming generation for the future.

Irma Alred 03436-017 Age 36
30 years, 10 months
Conspiracy to Distribute Marijuana

I was sentenced to 30 years and 10 months in prison to be followed by 10 years supervised release and $25,000 fine. My charge was conspiracy to distribute marijuana along with my now ex-husband and his brother as well as some other people I didn't know who were with them when they had drug transactions. There was no evidence against me other than hearsay from people who were granted everything from immunity to 30 days home confinement for their testimony. We were all facing the same penalties under the federal sentencing guidelines. I proceeded to trial and was punished further by getting enhancements for a gun my co-defendant had (which was also hearsay by the same man who admitted to being a cocaine abuser who would stand out in the pouring rain seeing things from too much drug use) and an enhancement for "king-pin" status. It's amazing how one can receive so much time behind bars for hearsay by people who stand to gain so much by lying. I just can't believe that the government can tell somebody that you're going to jail for 30 years, but if you place blame on this other person, you'll only do 30 days on an electronic home monitoring system which you wear on your ankle. The probation officer advised against the fine because I don't have any money, but the judge assessed $25,000 anyway. Now I have to pay half of my prison wages (which begin at 12 cents per hour) to the government. I have two lovely children who are now entering adulthood. I try to explain to them, but it's so difficult to tell a child that one can go to prison for over a quarter of a century for the acts of other people which I didn't even know about or what they were doing. All that happens in conspiracy is that person A can be dealing drugs with person B, and because person C is on the indictment, they are punished for the acts of A and B. It's really unfair and the punishment sure doesn't fit the crime – if in fact a crime was committed. The government tapped my phones and heard the word "jackets" and told the jury that jackets

meant pounds of drugs. I owned a sewing business and jackets meant jackets. To make matters worse, I also owned acres of land and farmed crops and raised cattle. Any time I mentioned a vegetable or a cow, again, they told the jury it was all about drugs. I guess since there were no drugs in the case, the jury probably thought the government forgot to bring them, because I can't figure out how 12 reasonable people would convict without any evidence. I guess they see the U.S. Attorney and he says "I represent the United States of America" and immediately people think the government is in the right. After all, a person wouldn't be indicted if he or she wasn't guilty, right? Wrong. Conspiracy can happen to anybody, and even juries aren't told of the outrageous sentences which are served. Most people think there is a parole system or lots of good time days. One receives 54 days off a year for good time and there is NO parole. I've served six years and have to serve another 25 years. By then my children will be grandparents, if I live that long to see it happen. Irma C. Alfred

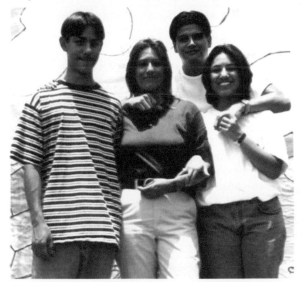

(l. to r.) Antonio, son; me, Irma; Juan Jr., adopted son; Tania Michelle, daughter

THE TALLAHASSEE PROJECT

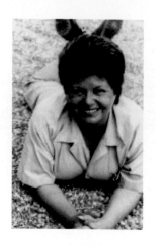

Mary L. Ames 21692-018 Age 51
3 years 9 months Conspiracy/cocaine

My story: From 1993 to 1997 I was investigated, harassed, and attempted to be entrapped by the local police. Search warrants were denied for my residence, but 200 phone tapes gathered for months from June to Sept. 96 proved no probable cause. I was indicted 1 year later from the conspired testimony of my son's ex-girlfriend, Becky East, whom I admit that I tried to discourage him from dating for his safety. She found a way to reduce her sentence by 10 months and get revenge on me and make the local police look good.

So after hiring and firing 3 different attorneys, backed into a corner like a rat, traumatized and confused, I plead guilty to 2 kilos of cocaine over a three year investigation for a 46 month sentence. I was told I would get a 20 year sentence if I went to trial. My choices weren't much, suicide, running, or 46 months at a nice camp near my home. I made my choice and had no problem facing the consequences, but instead I was sent to the worst prison for women in the whole country, FCI Tallahassee, where I am forced to live in fear and paranoia from the inhumane living conditions we must endure. I pray that God helps me to keep my sanity so I can be a functioning human being when I am released, if my health holds up from the medical neglect I must endure.

God told me in prayer: "A prisoner must learn to scream in silence, it is better than being ignored." Please hear my screams.

My father is 78 years and truly needs me now in his final years. Perhaps house arrest could serve the purpose?

Suffering at the hands of injustice,

Mary L. Ames

Letter , undated, in response to questions:

My son's ex-girlfriend, Becky East, is presently doing her little time in Bryan, Texas, as she was arrested in the act of purchasing ½ K of coke. She was sentenced to 71 months originally, then the government gave her a 10 month reduction after I signed a plea agreement to 2 Keys of C. I was told by my attorney that the government was trying to prove 20 K, so I better plea out. Apparently they knew what amounts she was purchasing and the majority of it was going to her mom, Patty East, who must have gotten immunity along with Becky. She lied about the amount I was purchasing. The attorney said if I went to trial I would probably lose.

Martha Ayala 33303-004 Age 62
13 years Conspiracy

First ofender, non-violence. I had done 10 years. Destroyed all my family.

Janette Andreu 19578-018 Age 55
10 years, reduced to 7
Non-violent drug offense

Report by Becky Stewart: Janette's picture was taken before sentencing. Nowadays she wears standard prison garb.

At the time of her arrest, Janette was 51 years old. She was the mother of three sons, and has five grandchildren.

Janette pleaded guilty to a conspiracy, knowing that if a drug offense is taken to trial one is given more time. Janette's family knew that she wasn't a drug dealer as the government was portraying her, but that she was drug dependent. Even though she told the government exactly how many drugs she purchased, she was still charged with three times the amount. The family hired an attorney, paying him $15,000 to file an appeal. Four years later, she won the appeal, and her sentence was reduced to 7 years.

Janette is now 55 years old and is still serving time. Wouldn't it have made more sense to commit her to a drug rehab where she could receive treatment as opposed to locking her up for 7 to 10 years where one cannot get into a drug program until the last year of one's sentence? Janette will be close to 60 when released. Do taxpayers realize their money is going to warehousing individuals like Janette for year after year ... after year?

Stacey Lynn Arena 26804-083 Age 32
210 months 17½ years
Conspiracy to sell "crack" cocaine

I feel that such a long sentence for someone who was an addict for less than a year and tied up with the wrong people for 6 months is very unjustified. I had seen what drugs were doing to me and my 5 year old son and I were drifting apart, so I quit, totally disconnected myself from the drug scene. I was clean and leading a responsible life once again, 6 months prior to my arrest. There are a lot of similar cases to mine who received even more time. Please help us reunite with our children and families. Thank you!

THE TALLAHASSEE PROJECT

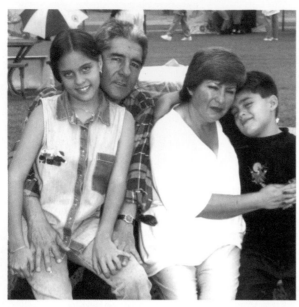

Esperanza Rodriguez Arevolo
46354-004 42 años

151 mes Posesion

Intento de Distribucion
(Caso de Aeropuerto)

Primera ofensa, a pesar de ser Jure en Colombia desconocia las leyes de este Pais y el Idioma. Mis hijos estan pequeños, requieren de su madre. Isabel 12 y Jaime 9 años: se encuentran en Colombia sin poder ventos crecer. Me eqivoque por no declararme culpable; pero solicito una oportunidad. Los abogados en su mayoria son desonestos y cuando tienen el dinero no se preocupan por el caso.

Note by Becky Stewart: Esperanza is from Columbia and was arrested in Miami on November 1, 1992. She is serving a 12½ year sentence of which she has done 8 years with 4½ more to go. The judge sentenced her to the maximum allowed under the federal sentencing guidelines due to her position in Columbia as a Juvenile Judge. Esperanza admits she made a grave mistake and has paid dearly for it, as well as members of her family. Because of all the publicity surrounding her case, Esperanza's brother was denied a promotion in his official capacity. Esperanza's children were 6 and 3 years old when she was arrested. They are now 14 and 11. Esperanza will be deported back to Columbia once she has completed her sentence. The taxpayers of this country are paying to keep people like Esperanza locked up for this ungodly amount of time. Wouldn't it make more sense to ship them back to their own country after a reasonable amount of time, as opposed to keeping them here for in some cases decades?

Joyce Ann Barringer 11546-058 Age 43

107 months (8 years 11 months)
Conspiracy to distribute and possess crack cocaine

I'm a 43 yr. old black woman, the mother of a 23 yr. old daughter who has 3 children ages 5, 2, and 7. My daughter has been mentally unstable for 5 years due to me being locked up. Me, myself have learned my lesson and will never break the law again, when ever I get my freedom back. The government is too harsh on the drug laws, and there is no justice in this society.

Marilyn Bello 10230-112 Age 29
24 years 4 months
Conspiracy to Distribute Cocaine

I had been living in California, but went back to Alabama to attend my grandmother's funeral. While in Alabama, I ran into an old friend of mine who told me she was selling drugs. I bought some for my own personal use and gave her my phone number in California. Months later she called me, wanting to know if there were any drugs available out my way. I told her I didn't know, that I'd have to check around. I did some checking and found what she wanted – powder cocaine. Later she ended up getting busted and told the police that it was my drugs and she was selling them for me. We had a buyer-seller relationship; she was not "working" for me, but I was charged with the conspiracy to distribute cocaine and extradited back to Alabama. My indictment read for powder cocaine, yet I was sentenced under the

I am the one who is sitting at the table.
My friend Lisa Taylor is next to me.

harsher penalties of "crack cocaine." She told the authorities that once she received the powder cocaine, her and her husband would rock it up, in effect producing crack.

Under the Federal Sentencing Guidelines – five grams of "crack cocaine" equates to 500 grams of "powder cocaine," it is a 1 to 100 ratio. Hypothetically, if a person is caught with five grams of "crack," the sentencing guidelines under federal law mandates a 5-year sentence, yet a person caught with 500 grams of "powder cocaine" would still only receive the 5 year sentence. This is one of the biggest disparities in sentencing. Under the guidelines, the higher the drug quantity, the more the prison time. Under the conspiracy law, you don't actually have to be in possession of drugs, all it takes is someone, whether he's credible or not, to say that he bought the drugs from you, and however much the amount is that he says he bought, is attributed to you. In my case, my friend (who was caught in possession of the drugs) only received a 5-year sentence, as did her husband. They were sentenced under the "powder" cocaine guidelines, but I was sentenced under the harsher penalties of "crack" cocaine and received 24 years and 4 months, plus 5 years supervised release. I was pregnant at the time and haven't seen my baby since he was three days old. I also have another 12-year old son. This is the hardest thing to live with, the separation from both of them and the rest of my family.

Yes, I made a mistake be getting involved with drugs and I deeply regret it, but feel that 24 years of my life for this first drug offense is extremely harsh. My sons will both be grown men by the time I am released from prison of which I will be 48 years old. There were no victims in my case, no violence, yet I am doing more time than murderers, rapists, and child molesters. This is hard for my family to understand.

Marilyn Bello

THE TALLAHASSEE PROJECT

Sonia Berrios 35694-004 Age 42
24 years Conspiracy

I have been incarcerated 9 years, and still have many more to go. The system is set up so that people who inform receive lesser time than people who don't. The person who determines how much time one receives is the prosecutor. Before the Sentencing Guidelines came into effect, the judge determined the sentence. It is not fair for the prosecutor to have the ultimate power of determining one's sentence. But this is the way of the American System. The system destroys families with these lengthy prison sentences. A change is in order! Please help repeal these drug laws. We are serving more time than murderers, etc.

Rosalyn Blackmon 14890-074 Age 39
180 months 15 years
Poss. with intent to distribute
Poss. of weapon on permise

I was sentence by the guidelines being a convicted felon in the state before of using and selling drugs. The weapon was never in my possession, I never have been involve in any violent crimes. My co-defent plea guilty in the state on this same charge of 2.3 grams crack and the gun. He receive 2 months county jail time and 6 yrs house arrest. A year and half later the feds came and got me on the same charge the state drop.

Now I'm serving this much time, rightly only for being a drug user, supporting my habit by selling some in order to use some. Nothing of quantity, just enough to support my habit. I have a sixteen year old and a 2 yr old that turns three this year. Being addict as I was I was still using when I got pregnant with my last son. By the grace of God he was born healthy with no side effects from the drugs. Now I have not seen him since he was a baby. Anything someone can do to help me will be graciously appreciated to the utmost. Thanks for your time and concern.

Ms. R. Blackmon

P.S. I've been clean now going on three years, and not because I had to but I choose to stay clean.

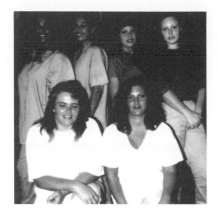

**Sonja Brockman 14665-047 Age 31
10 years 10 months
Conspiracy to distribute methamphetamines**

I was sentenced to over 10 years because my live-in boyfriend was dealiing drugs and I lived with him. I have 4 children at home in Nebraska several thousands of miles away. I cannot get moved until I've been here for 18 months.

Picture is of women who are all in prison for conspiracy. I'm the one with my eyes closed.

**Jacqueline Brown 10332-017 Age 33
14 Years Conspiracy to crack cocaine**

I wasn't a drug dealer, but the DEA made me one when they was through.

**Theresa Brown
47478-004
Age 31
Life Without Parole
Conspiracy to distribute crack cocaine**

Yes, I'm incarcerated, but I think that the public should know that I've been convicted of a crime that had no supported evidence (meaning they had no crack cocaine). I've been sentence to life without parole because of co-defendants testimonies to help the government convict me so that they themselves would not receive a harsh penalty as myself. (They are called informants for the Government.) If you would like any information pertaining to my case please let me know. I'm ready to speak out, but I don't know who to contact or how to contact anyone. Thank you for you'll support.

THE TALLAHASSEE PROJECT

Carla Buggs 19083-001 Age 35
324 months (27 years)
Conspiracy with Intent to Distribute Cocaine
Sentenced in 11th. Circuit, Northeast district of Alabama

I am a mother of five children. My baby was one month old when I was arrested. The government had no witnesses against me except one of my co-defendants (turned informant), who in turn was given three years and is out now. This was very unjust and cruel to me and my family. I received more time than my co-defendants who were actually caught with drugs in their possession. I was never caught. What kind of judicial system has the United States conformed to? Very unfair!

Denese Calixte 51291-004 Age 53
10 years
Possession With Intent to
Distribute

Denese Calixte sent a copy of an article written on her case and published in FAMM-gram November 1997 (Families Against Mandatory Minimums).

Denese is an illiterate Haitian immigrant. For much of her life she worked in Florida picking fruit for about $60 a day, enough to support her seven children. In 1994 she fell from a ladder while picking fruit and injured her neck and could no longer work. Jobless, she was unable to feed her children or pay the rent.

While struggling to make ends meet, Denese was approached by a man name Gerard who sold drugs in her neighborhood. He didn't like to carry the drugs around at night and offered Denese $200 to keep his supply of crack cocaine, stored in a pill bottle or cigar tube, in her house at night. Denese agreed and when the police broke into her house one morning, the drugs were there. She told the police the drugs were not hers, but she was charged anyway and was convicted of possession with intent to deliver crack cocaine.

Her three youngest children were ages 8, 10, and 12 when Denese was arrested. They now live with a friend of Denese's who cannot support them because she has children of her own. Denese's children receive no Christmas presents and can only afford to visit their mother three times a year.

Elizabeth Chapa 16145-074 Age 42
27 years
Conspiracy to distribute cocaine

On June 5, 1998, me and my family were getting ready to attend my daughter's high school graduation when the police busted into our home and arrested me. They read me my rights and told me I was under arrest for conspiracy drug charges. Later I found out there was a ninety-six count indictment handed down by the Grand Jury that ultimately led to the arrest of nineteen more individuals; half of these people I did not know. I was named in only one count of the ninety-six counts and charged with conspiracy to distribute cocaine. I proceeded to go to trial because I knew I was not guilty of the charge. My attorney advised me to take a plea bargain because exercising one's right to trial always ensured a longer sentence in most drug cases. But because I believed in the system, I went to trial. At trial, six of the twenty co-defendants testified against me. They said that I delivered the drugs to them by motor vehicles. I haven't had a drivers license for twenty years. Common sense says that someone wouldn't want to carry and deliver drugs in a car or truck if one didn't have a license. Each and every one of these men that testified against me received downward departures (time reductions) for their testimony. They had taken plea bargains instead of going to trial. In order to get one's sentence reduced in the federal system, you must give information on someone. I found out it doessn't matter if the information is true or not. I am doing 27 years in prison because these six men said at one time or another they had received drugs from me. I still remember the nightmare of the trial. I could not believe how these men could get on the stand and lie and be believed by the jury. I did not even understand half of the things that went on at the trial. I did not even realize that I had been sentenced under the harsher penalties of "crack cocaine" until after I had been in prison for a little while and one of the women pointed it out to me. I kept thinking the jury would see through those men, and realize they were just trying to get their sentences reduced pursuant to their plea bargains. I knew I was innocent of what was being said about me, so I thought my trial would reflect that, but being ignorant of law procedures I finally realized, too late, that one must plea bargain and never go to trial in order to get a lower sentence. And if I could have made up some lies, maybe I wouldn't be here right now.

I have five children, one (my son) was also arrested. He was given five years. He took a plea bargain.

Asked to elaborate on her trial, Elizabeth Chapa wrote:

I was charged with Conspiracy to Distribute Cocaine Hydrochloride and Marijuana. True, I have had past dealings with marijuana and a little cocaine, but it has been a small part. When these other conspiracy counts started coming down on these men that testified against me is when I got drew into the conspiracy. My involvement was blown out of proportion and I was portrayed as a major drug dealer. I was ultimately sentenced under the stiffer penalties of crack cocaine, when I have never been involved with crack. The sentencing penalties are different for powder cocaine versus crack cocaine, and yes I have messed

around a little with powder, but never crack. But this is what I was charged with in order to stiffen my punishment range.

Throughout my court proceedings, I had no knowledge and understanding of the law. I could tell my lawyer did not have much experience with federal law himself. When I would ask him questions, he would reply, I don't know, I will have to go to the law library and look it up. That is a scary feeling when you know your life is in his hands.

Our judicial system is not based on the truth, it's based on how to acquire the biggest conviction. I couldn't understand how other drug dealers (major players) could testify against me and make my part seem so much bigger than theirs, and how they could receive reduced sentences based on lies. That is how our judicial system works though. I found that out and I am paying with 27 years of my life. It hardly seems fair.

If you need any information, please let me know. On the photograph, Crystal is in the yellow shirt, Isabel is in the red.

Thank you so much for your dedication.

Sincerely, Elizabeth Chapa

P.S. They pick me up on June 5, 1997

Accompanying this letter are a photograph and statements by Elizabeth's two daughters, Isabel Vasquez and Crystal Virgil:

To Whom It May Concern:

I am the eldest daughter of Elizabeth M. Chapa, my name is Isabel Vasquez. I am writing to ask you to please evaluate my Mother's case once again. My Mother was not Jesse Moreno's partner as portrayed to be. That was one of the biggest deals of this case. There were so many lies that were told about her, especially on the day of her trial. I believe she does not need to spend a large number of years in a Federal prison. She is a Mother of five children and a Grandmother of seven grandchildren. Three of her children are under the age of 18 years old. They need their Mother in there lives on a day to day bases. My Mother has been in there long enough to understand and pay for what happened. I am asking you to please evaluate this case and find it in your heart to give my Mother Elizabeth M. Chapa another chance in life to enjoy her children as well as her grandchildren, because the one person we are missing in our family is our Mother. Sincerely, Isabel M. Vasquez

To Whom It May Concern:

My mother, Elizabeth M. Chapa, has been incarserated for two years of my life. For something she had little to do with. She will still be incarserated for another 20 years or more. She got locked up when I was 15 years of age, just starting my high school years. It has been so hard for me without my mother. I miss her dearly and there is not a day that goes by that I don't think about her. I have been so hurt and confused these last past two years and I seriously believe that it's because of my mother not being here for me. It would not be all that bad if I had a father, but my mother is all I really have in my life and she's not here. Please, take the time and look at this case very closely. I miss my mother, please let my mother come home.
Sincerely, Crystal R. Virgil

Debroah Chisholm 09967-058 Age 45
14 years Conspiracy/heroin

Mother of one, an one has past since my incarceration, I'm miles away from my son an haven't seen him since 96, and miss him very much. I've been locked up for 8 years, went home 2 years ago for my baby boy funeral.

Debroah Chisholm in center

De-Ann Coffman 23046-077 Age 27
Originally Life plus 5 years,
reduced to 85 years drug offense
first time offender non-violent

I am a white-native American female, and was never in any trouble in my entire life. I am a first-time offender of a non-violent crime and have been fighting for my freedom since May 16, 1992. My original sentence was Life and 5 years for a conspiracy I was involved in for five months. I was dating the leader of the organization and had only known him for ten months prior to my arrest.

My LIFE AND FIVE YEAR sentence was reduced to 35 years on June 21, 1996, due to a Motion 18 U.S.C. 3582 and U.S.S.G. 1.B.1.10. On April 10, 1997, my thirty-five year sentence was vacated and case remanded to the district court

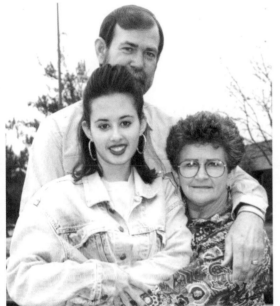

Dec. 94 This is my visit with my father and step-mother!

for resentencing, due to my conviction for violation 18 U.S.C. 924 (c) (1) being reversed.

On February 26, 1998, I was sentenced to 85 years for the same offense "MINUS" one charge of 18 U.S.C. 924 (c) (1) "PLUS" a conversion of crack to powder cocaine on Count 2, Possession with Intent to Distribute 833.5 grams of cocaine.

Therefore, all of my current charges have an eligibility of probation. Relevant conduct allowed the judge to give me a base offense level of 38 and 6 additional points which carried a mandatory minimum of Life in Prison. Since all my charges run consecutively only hold 85 years, I could not again be given a Life Sentence. Instead, I was given the maximum of 85 years which is 73 flat years with good-days. I will be approximately 94 years old when I am released from prison (if I live that long)!

There was no violence committed in or connected with my crime; however, due to the manner in which our government has set up the sentencing guidelines in the Federal System,

THE TALLAHASSEE PROJECT

I will live out the rest of my life in prison for a mistake I made when was was 20 years old. I see no justice in this and I belive, as a first-time offender of a non-violent crime, I DESERVE A SECOND CHANCE.

I truly appreciate your time and efforts.

Sincerely,

De-Ann Coffman

[Letter December 29, 1998]

I am pleased to hear from you. I was snatched up from Tallahassee rather quickly because of a food strike. Now I am here in Danbury trying to transfer to Texas close to my family. There is a great deal of women here wth outrageous sentences.

My sentence is still 85 years and my Public Defender says that my appeal is hopeless. I hope that he is wrong. Even if I were to be granted my appeal for the second time I am still doubtful of the outcome. My Judge is older between 65-70 years of age. He shows no emotion or concern and definitely no sympathy. He obviously believes totally in he Criminal Justice System and ignores the prosecutor's misconduct. He never has any facial expression even when he re-sentenced me with 50 more years for the same exact case, not more charges but less. The jury consisted of people who had no knowledge of drugs or the actions that went with them. The prosecutor was a ruthless female and breaks all rules to get a major conviction. Since my trial she has been demoted after a sanction due to her misconduct (lieing in court). Now I have another female who was her supervisor that obviously plays by the same rules.

My boyfriend is in Englewood serving a Life sentence with all appeals exhausted. He did not testify against me, but his wife did. She is free and always has been.

Basically being a Native American and White in here has been an experience. Very few women's prisons fully acknowledge our Native American religion and/or our culture. I was raised as a White female and it has been a struggle to learn more about my heritage especially in here. My appearance causes a great deal of confusion. People never guess my nationality and the majority of the time approach me in the Spanish language. I am blessed that I can relate to all nationalities, because I am not totally accepted by any certain one.

March 2, 1999 in response to question asking if she works for Unicor:

I don't work for Unicor. I don't believe in it. They make cables for the military weapons here.

Pamela O'Hara Cooper 08087-021 Age 43
40 years
Conspiracy to possess with intent to distribute a controlled substance.
Possession with intent to distribute cocaine and cocaine base.
Using a firearm during a drug trafficking offense.

My name is Pamela O'Hara Cooper. I was born in Waycross, GA. I was sentenced on June 16, 1993. My only son, Benjamin Lashon Cooper, age 27, was also a first-time offender. I have two daughters, Juanita Perkins, age 26, and

Alexis Cooper, age 13. When I was arrested, Alexis was 7, and now she will be 14 years old on Jan. 9th. We really don't know each other anymore. I talk to my son every 90 days. Juanita takes care of Alexis because my mother is 73. She can't take care of Alexis any more due to her age. Juanita has two kids of her own and a husband. She got married right after high school when I came to prison. My mother took care of Alexis until 3 months ago. Juanita took her because she said Alexis is the only family she has left. When I saw Alexis after five years at visitation, I didn't know who she was. I walked right past her. She had to call out to me. I've met my grand children once. This prison time has jurt my kids more than me. I missed Juanita's high school graduation, her getting married, and the birth of her two kids. Alexis is 13, the age when she needs me most. My son is growing up in prison.

I have never sold drugs in my life. I got caught with drugs in my car because my boyfriend asked me to do him a favor. He asked me to go to Florida and pick up a package from my cousin. The gun charge is there because when I stepped off the train, the guy who picked me up was driving my car and my gun was in my glove compartment. I have never been to jail in my life until this happened. I've always carried my gun in my glove compartment and the gun was bought legal. It has never been used in my life.

My life has little meaning ... because my kids were my life. I have lost so much. What life I have left, with the length of time I have left to serve, my kids and grandchildren will be adults by the time I get out. And I wonder what will be left of my family by then?

Photo captions: From upper left to lower right, clockwise: Juanita at the cemetary, Benjamin in prison ("To my Mom with much love"), Alexis, Pamela Cooper.

Katie Mae Core 07961-021 Age 52
12 years Conspiracy to possess with
intent to distribute cocaine base

Mother of two, doing a mandatory drug sentence. This war on drugs has been a dismal failure and it is tearing families apart. We need a change! P.O.W.

Rosa Cruz
33346-004
Age 48

14 years 10 months
Conspiracy to possess cocaine

My children have grown up all on their own and I just think the family bond disappears when you are a decade away from your kids. Why must our children suffer for our mistakes? I am 13 months short and I thank God I have pulled through all these years with my kids. It is not so easy for mothers to leave their children for so many years!!!!

Rosa Cruz is second fro right

THE TALLAHASSEE PROJECT

Marsha Cunningham 30862-077 Age 27
15 years Possession with intent to distribute cocaine base and cocaine
Aiding and abetting

At the time of my arrest I was 26 years old. I was feeling as though I was beginning to live my life and accomplish certain things. I had a good job at a mortgage company in the foreclosure department, a nice condo, two vehicles (one paid for). And to make my life complete, I met a man who I fell in love with. After a while of dating, I let that man move in with me. He had keys to my house, cars, and heart.

On August 5, 1997. my world was turned upside down. I returned from work that day to a house full of DEA agents. I was informed that my boyfriend had been arrested earlier during the day for drug trafficking. Then they arrested me because they found drugs in the storage compartment at the bottom of the stove.

I was taken to the FBI office and questioned about the drugs. I told them that I didn't know anything about the drugs and that they were not mine. The agent told me that he knew that the drugs were not mine and that my boyfriend had told him the drugs were his. But the agent felt that I knew where my boyfriend got the drugs. But I didn't and still don't.

Because of my lack of knowledge and having a boyfriend that I could not keep my eyes on 24 hours a day the government punished me by sentencing me to 15 years in prison. I was found guilty by association.

Everyone makes mistakes, and nobody knows what all goes on inside their home when they share it with someone else and is gone from home eleven hours a day.

I always thought that I was protected by the constitution. I thought one could not be convicted if there was a shadow of a doubt. In my case, the government said that because my boyfriend was a drug dealer, lived with me, and drove my car, therefore I knew what he was doing and was guilty of the same crime. But other than my boyfriend living with me and driving my car, there was nothing to link me to his illegal activity. I was never seen by DEA agents with my boyfriend at any of the drug transactions. No drug sales were conducted out of my home. I never took phone messages for him. He never conducted illegal activities in my presence.

If I was suspected of assisting him in his illegal activities, why wasn't I put under the same surveillance as my boyfriend? Why was my name not on the search warrant to my apartment? Why was I not even mentioned in the search warrant? At my trial the DEA agent testified that they knew about me but I was never put under surveillance because there was no need. They knew who the drug dealer was. And he is serving a seventeen year prison sentence, two years more than me!

The criminal justice system thought that harsher sentences would help win the war against drugs, but it hasn't. All it is doing is locking up more people, and causing children to grow up without mothers and fathers. Society needs to realize that our legal system has failed. The criminal justice system has been turned into a big business. Until society addresses the causes of why they are building more prisons and locking up more people, the system is

going to lock up even more people. People should admit the system has been tried and failed.

There are a lot of people incarcerated now with lengthy sentences, and not because they were kingpins in big drug rings. Many were just friends, girlfriends, or wives of mid-level drug dealers.

Some were users, needing drug rehab and not years in prison. Many are in prison under the conspiracy or aiding and abetting laws because they were assoicated with someone who committed a crime.

It costs the Bureau of Prisons $22,000 a year to incarcerate me. And I am expected to be here for 15 years. America spends more money on incarceration than it does on education.

People who are least culpable are doing the most time. Addicts are doing more time than their suppliers instead of being in rehab and learning to kick their addiction. Murderers, rapists, child abusers, and robbers routinely do less time than non-violent drug offenders. Drugs are a problem in America, but mandatory sentences or three strikes legislation is not the answer.

How many billions of dollars is America going to spend on prisons, while the problem continues untouched?

Marsha Cunningham, POW

Martha De Diaz 50830-053 Age 42 57 months Conspiracy to import a Schedule II Controlled Substance "HEARSAY"

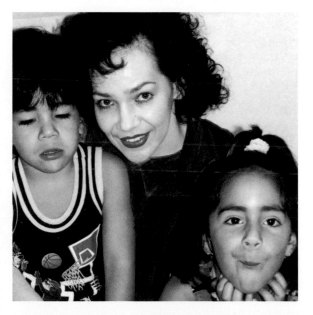

MOTHER OF FIVE CHILDREN. One in college other in the U.S. Air Force and the youngest attending elementary school. Legal permanent resident of this country for the last 19 years, never been arrested, hard worker and a single mother, now without choice I have to return to my country leaving my two oldest kids, my family an everything that I work for during this 19 years. Actually my family be dispersed, each of my children are in different friend or family house. Two of them inclusive out of the country, thus I haven't seen them since I was arrested three years ago (the youngest 1 year old). Here are so many women in the same conditions, serving very long sentences just because they didn't accept turning in their chldren, husband, brothers, etc. or like my case only with the testimony of a prior offender trying to reduce his sentence, no others evidence was presented.

I pray and hope that all of you help to make the changes, and the difference to have a better justice system. Thank God and bless all of you.

THE TALLAHASSEE PROJECT

Frankie Delise 40043-037 Age 44
25 years Non-violent drug offense

Becky Stewart writes: Frankie Delise is a first-time offender. She was sentenced to 25 years in prison on December 9, 1998. At the age of 44, her only past criminal record was a citation for failure to wear a seat belt. Ms. Delise accepted a plea bargain because her attorney falsely told her she could receive 350 years. Knowing that these type of sentences are common for drug offenses in the federal system, he scared her into accepting the 25 years making her feel that she was getting a real "bargain." Her attorney also failed to inform Ms. Delise that when she signed the plea agreement, it contained stipulations that waived her right to appeal her sentence. Many non-violent drug offenders are in her position, sitting on these elongated sentences with no hope of appeal, knowing they will spend the next 25 years behind bars. Ms. Delise's release date is April of 2020.

Diane DeMar 41010-019 Age 51
Life + 5 years

Eddie DeMar 40964-019 Age 56
40 years + 5 years = 45 years
Conspiracy, non-violent offense

Eddie and I have been married for 34 years. We have 2 children ages 29 and 27 – Michele and Aaron. We have a grandson (Austin, 2 years old) and my parents are 75 years old. We were a close family and there is no one to take care of my parents except my sister who is now ill due to the stress of trying to handle everything alone. Eddie and I are needed so badly at home. With our sentences, mine (Diane's) being a life sentence plus 5 years, I will not have a chance of going home. And with Eddie being 56 years old and with a sentence of 45 years, he may as well have a life sentence too. Yes, we made mistakes, but to spend the rest of our lives in prison for a non-violent offense is not justice. These drug laws need to be re-evaluated. We could still be productive citizens if given another chance. We both would never again mess around with drugs if given another opportunity at life. We just want to go home and take care of our family.

Asked to elaborate, Diane DeMar replied:

On April 5, 1990, while checking into a motel, police arrested my huband on a warrant for questioning. They had no warrant for me but proceeded without probable cause to search me and my purse. Before searching my purse, I told the police that I did have a gun in my purse and that it belonged to my husband. They also found two ounces of meth. This occurred in the state of Georgia. On the following day after my arrest, I was let out on

my own recognizance and returned to Florida where my husband and I had been business owners for 25 years.

On June 5, 1990, I was subpoened I front of a grand jury in Atlanta, GA, and because I had no information they wanted or knowledge of the people they were interested in arresting, my case was turned over to the federal government were the penalties are much stiffer than the state penalties.

I was then in the federal courts linked to thirteen people, most of whom I had never met. Ten of these thirteen people pled guilty. Myself and two others went to trial. Three people among the conspirators testified against us who went to trial. This was the only way for these people to get their sentences reduced. At trial, one of the three who testified gave testimony of different amounts of oil manufactured in the conspiracy and the amount of six gallons being the most. Then after trial in his pre-sentence report he stated 31 gallons. The 31 gallons mentioned in the pre sentence report, but not at the trial, is what brought my sentence up to LIFE. The district attorney came to the conclusion that 31gallons times three would be the amount of methamphetamine made which equated to a total of 93 pounds of metamphetamine which I was ultimately sentenced for. The person who gave this testimony got his sentenced reduced to 11 years.

With the conspiracy charges against us, all that was needed, was for one person -- whether he knew us or not -- to just say that he knew of the crime, and to say what the government wanted to hear to get us involved in the conspiracy. Another co-conspirator, an escapee from Florida, also testified in court. His sentence was a mere two years in state prison with the conspiracy charge dropped.

At the time of my sentencing, the Guidelines had been changed to not let anyone with L-meth [the levo isomer] be subjected to the stiffer penaltes of D-meth [the dextro isomer], which is a stronger type of methamphetamine and carries a much higher sentence. The methamphetamine was never tested and I was subjected to the stiffer penalties carried for D-meth.

I am 52 years old, my husband is 55 years old. My husband also received a LIFE sentence, but his sentence was reduced to 40 years. We have two children and two grandchildren. My elderly parents need me at home. They are 75 years old. My father has had one leg amputated since my incarceration. My mother needs surgery on her legs. They have no one else but my sister, who does all she can to care for the whole family. She works to support myself and my husband since in prison our monthly wage together only equalss $30. One doesn't realize that prisoners must buy everything from shampoo to shoes.

We have always been responsible tax-paying citizens. We need to be taking care of our loved ones instead of them taking care of us. We feel the past eight years we've spent in prison our lives have been wasting away for a non-violent crime. My husband and I have deteriorated greatly over the years. We will soon be more of a burden on the tax-payers as our medical bills escalate. The way it stands now, me and my husband will be incarcerated in prison until our death.

THE TALLAHASSEE PROJECT

Sharron Dueitt-Jackson 02854-003 Age 48
10 Years plus 5 years "Special Parole"
plus $15,000 fine
Possession of marijuana and cocaine

Note by Becky Stewart: Sharron is currently serving a second federal sentence for the same federal offence.

My name is Sharron, my friends call me Sharrie, and I was arrested for possession of marijuana and cocaine at age 32 on January 30, 1985. My mother Nell and a friend Richard were also arrested. I was sentenced under the "Old Law" sentencing system when there was still parole available. After 3½ years I was paroled on my 10 year sentence, but am now serving my "Special Parole Term" that was added to my original 10 years.

A Special Parole Term is a sentence added on top of a sentence. SPTs were abolished in 1987and Supervised Release replaced them. Because I was sentenced in 1985, I am still under an SPT. Special Parole Terms were created for harsher punishment for drug offenders. The unique characteristic of an SPT is that if one violates while serving an Special Parole Term, all the time you have done on it is taken away and you start the term over again. This is what happened to me.

I was 32 years old when I began my first sentence. I paroled out in 1989 and was placed on regular parole. I did well on parole and in 1995 my original sentence of 10 years was completed. Then I was placed on my Special Parole Term of 5 years. I worked, made my fine payments, and never gave a dirty U-A. I completed 4 years, 11months, and 9 days of the SPT, then I violated. I am now serving my 5 years over again. All of the time was taken away from me, and the whole 5 years was accredited back to me. When you are a drug offender, any little thing can send you back to prison.

My daughter's home was broken into. Unbeknownst to the would-be burglar, my daughter's boyfriend was asleep on the couch. When he heard the window break in the front door, he woke up. He recognized the man who took off running. We had other property nearby and went to check on it. When we arrived at our cabin, the guy that had tried to break into my daughter's home was asleep on the front porch. A disturbance occurred and the police arrived. Me and my daughter and her boyfriend were arrested on assault charges. I was violated and sent back to federal prison to begin the 5 year sentence again. I am now 48 years old and will not finish this sentence until 2004. I only had 22 days remaining on my 5 year Special Parole Term when I was sent back.

I look back and reflect about the years. My mother was also sentenced to 3 years prison time when we were arrested in 1985. She lost her home and 10 acres of land that was given to her in her divorce proceedings. My co-defendant Richard took the stand at trial and told the court my mother didn't know the marijuana was stashed on her land. It didn't matter. They still sent her to prison. I will always carry the guilt with me for my mother having to serve time in prison and losing the home she lived in for so long.

It's hard for me to believe that I am still serving time for the cocaine and marijuana charge. The fact that the guy was trying to break into my daughter's home did not come into play. All that mattered and was expounded on was that I was a past drug offender. It sure doesn't seem fair that after 16 years I am serving time in prison for my drug offense that occurred in 1985.

Sylvia Elang 40730-004 Age 42
8 years 10 months
Crack

I am married. I have 8 children. I am a Haitian citizen. I have been in this country 19 years and I will now be deported. This was my first offense.

Maria Ellis 61998-079 Age 38
15 years 8 months Conspiracy

Maria Ellis did not make a statement.

Joyce Enos, standing at center

Joyce Enos 15362-018 Age 51
188 months
(15 years and 8 months)
Conspiracy to commit drug trafficking crimes (crack cocaine)

I am the mother of five children and the grandmother of five grand-children. I was convicted and sentenced for the guidelines for crack-cocaine even though the alledged drugs found in the possession of a co-defendant was testified by authorities to be powder-cocaine.

THE TALLAHASSEE PROJECT

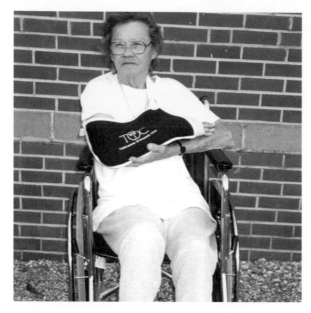

Lois Dell Fait 18530-018 Age 65
11 years 3 months
Conspiracy to Distribute Cocaine

I lived in Florida nearly all my life and have always been a law-abiding citizen. When I found out that my mother was dying of cancer, I moved to Roanoke, Virginia to help care for her. There in Virginia my whole life took another course.

I met a younger man who led a different lifestyle than me. He introduced me to a woman that had a past history of drug involvement. Together the two of them, introduced me to a totally different way of living. I still don't quite know how it happened, but one thing just seemed to lead to another. The woman got busted for selling drugs, and after that needed a place to store her drugs. This younger man I was dating talked me into letting the woman keep the drugs at my house. Whenever the woman needed some of the drugs to sell, she would come by, pick up what she needed and my boyfriend would get some drugs for his own personal use for storing the drugs at our house.

Looking back, I realize meeting this younger man, was the turning point in my life. My mother had just died, this younger man was paying me lots of attention -- I was very vulnerable at this point in my life. It seems I couldn't help myself when it came to him, I would do anything he wanted.

Well one thing led to another, and I started selling a little drugs here and there. One night in Feb. of 1995, I got stopped in my car by the police. They found drugs and proceeded to tell me that they knew I was working for this woman, and if I would tell them everything I knew – they'd let me walk out scot-free. So I did, I told them what they wanted to know. I went back to my house with the police following me and they recovered the drugs out of an old car that was in my backyard. I fully cooperated as they had asked.

I continued living at the house for a little while, but finally came to my senses and decided to get out of this life. I packed everything up and moved back to Florida.

In June, four months after the incident with the police in Virginia, I received a phone call in Florida from the police. They wanted me to come back to Virginia and help bust the case against the woman and others involved. They promised I would only receive a couple of years in prison. At this point I was scared, I knew I had already gotten out of everything, so I told them I didn't know what they were talking about. I guess I shouldn't have done this, but I was scared and didn't know what to do.

Then, in October of 1995, the police came and arrested me and I went to jail and was charged with conspiracy to distribute cocaine. When I went to court, my lawyer said if I didn't take a plea bargain to 10 years, then I would probably receive a LIFE sentence. So I agreed to a plea agreement of 10 years, but ultimately received 11 years and 3 months.

I've been in prison for approximately 5 years now. I am 69 years old. Since I've been here, I went to work in UNICOR, the prison industry for inmates where I made approx. 46 cents an

hour. I worked there for about a year operating a drill press that makes holes for furniture. There were no guard rails that accompanied this machine. One day my hand got caught in the drill press and smashed my left hand. I received $55.00 a month for a year under workman's comp and still only have partial use of that hand. After the workman's comp ran out, I had to go back to work to support myself, I went back to work with a cast still on my hand and operated a small router. After approx. 6 months, I mangled my right hand (my index, forefinger, and tip of ring finger). A plastic surgeon pieced the fingers back together, but ultimately I lost most of the feeling in all three.

In Sept. 4, 1999, I slipped on an oil spill from a forklift and broke two major bones in my right arm which jammed down into my wrist. I now have another cast on my arm. So my stay in prison hasn't exactly been good for my health.

For someone who was always a law-abiding citizen most of their life, this experience has been quite traumatic. I know I made mistakes, but I still can't understand how I became the leader of tis so-called conspiracy drug ring. The other woman had previously been busted for drugs before the second time she got busted, yet she only received a 5 year sentence, compared to my 11 years. I guess in our judicial system, mistakes are not taken into account. I would have thought my 65 years prior to my trouble, would have accounted for something. For 65 years I had never been in any kind of trouble, but for that first introduction around drugs, I will pay for that mistake for 11 years of my life, well more than that considering I still have to complete 5 more years on paper for supervised release. I believe this punishment is harsh, but that is the law. I will be in my seventies when released from prison, and this is what they call justice.

Ada Fernandez 34698-004 Age 30
10 years 1 month (121) Conspiracy

I'm a mother of 3. I've been away from my children for 9 years. I've lived in Miami from the age of 11 and now at the computation of my time I will be deported from the only home I've known for all these years.

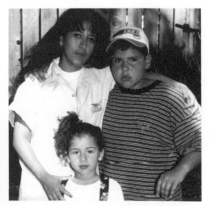

Saira Florez 30579-004 Age 33
188 months Conspiracy to import cocaine

I have two children, one 10 years old and the other 5 years old. They's father and me are incarcerated. Our children are proximately to come to live in a childrens home due to the fact that we haven't relatives here and haven't income to provide for them.

Asked to elaborate on the condition of her children, Saira Florez wrote:

To start from the beginning, I was in a state where we had a pretty home where a lot of peace and happiness existed.

THE TALLAHASSEE PROJECT

We had two children: Danny Alejandro (11 years old) and Melanie (5 years old). These children in a matter of seconds lost their parents, their home and the security that comes with having a family.

We resided in Miami, Florida, and their lives were here in this country. For that reason, Columbia and our family was completely unknown to them.

At the beginning of this nightmare, we thought everything was going to work out and we pretended everything was the same. Although, the more we began to understand and learn of the famous federal system, the more we discovered there was no easy solution, because it's so easy to enter – yet so difficult to get out. That is when we decided to send our children to Columbia.

Let me also say because of things of my destiny, my children have different fathers. I could only count on one family; my grandmother, my mother and my sister were the ones who became responsible for my children. Well, in reality, it was my grandmother of 82 years who took on the responsibility for them.

We had a lot of problems such as economical, the children being able to adapt in another country to another language, other customs, and a different economical status; not to mention the treatment and care were completely different.

My son was the one more affected and he began to show his frustrations by isolating himself and staying to himself. He attempted to commit suicide as was placed under psychological treatment and had to attend a special school. There were so many things combined that were suffocating him; the absence of his parents, attending a new school, and having new classmates. Since he was raised in this country, he didn't know how to read or write Spanish so he was under a lot of pressure trying to keep up in a Latin country. My family verbally abused him and treated him and his sister differently. With each day, my son became more distant and rebellious.

I could go on telling so much more but truthfully I would never finish. The fact is after two years and many problems, I was finally able to bring my children to live in Tallahassee, Florida, to be close to me during this period of incarceration. They were able to come live over here due to being sponsored by the Children's Baptist Home.

I was going crazy between my and my husband's sentence, and the problems my children were going through; their needs, their traumas, and their pain. In the effort to save my children's future and to rebuild the relationship between mother and children, I searched and found these people and this home, where my children now reside. It has been the best blessing the good Lord has given me. Now, for the last six months, my children are receiving a good education and most importantly, I am nearby where we can try and rebuild our relationship. I call them daily, and I see them twice a month; and we also write each other. I am a little more of what a mother is suppose to be and not just a voice they hear on the phone every ten days for five minutes. I am not a stranger or just a strange voice to them anymore. It does not take the place of me being there with them, but at least this way, they still have a connection with me.

Me and my son have always had a special relationship and we together are like one, but he has tried to cope with all the suffering by himself. Now that he is a young man, he has been able to better understand the many things I've tried to explain to him. Although obviously, he is still a child and needs his parents and a home to call his own.

My daughter is now five years old -- still a baby. Although I've re-established a good relationship with her, she still can't accept the fact that her mommy must stay in prison for such a long time and she must live alone.

They will never understand why they don't have a home and can't be raised with their parents. They must learn to survive by themselves and walk the hard roads that this life has dealt them.

Like my story, there are thousands and thousands of destroyed homes and lives due to the infamous "War on Drugs" which is the worse injustice that there is.

They are planning a terrible chaos where the children of today are tomorrow's future. A society which will be filled with hatred, vengeance and harsh feelings because our children hold in their heart what tomorrow they will display.

Bambi Dawn Gammell 13515-064 Age 26
5 years Possession of drugs (methamphetamine)
Non-violent offense First-time offender

I am a mother of 3 children and a stepmother of one. Even though there is another FCI [Fed. Correctional Institute] within 200 miles of my home, I was sent across the country to another institution. I have little hope of my children being able to travel 800 miles to visit. Not only am I serving the five year sentence, but so are my children. To Toni, Amber, Ashure, Taylor: Mommy loves and misses you all very much!

She sends details of husband

(written on back): Oakdale January 98 Always Be Mine!

Gary Gammell 13516-064 Age 44
13 years drug offense

I love my wife and children (Toni, Ashure, Amber, and Taylor) dearly. I pray for their happiness and health. I also thank those who care for them, who have had to explain where "Daddy" is. My wife is also in prison. All I want is to have my wife and children back together again.

Letter Nov 30, '98, excerpted

I was transferred to [FMC] Carswell [the federal Bureau of Prisons hospital] awaiting surgery for my gallbladder but the main reason I am here is because this is my home region. I am happy to say that I am getting to see my children monthly. Also, for the most part, the staff here recognize us as humans. They are an entirely different breed from what I encountered in Tallahassee.

I have told my family about the Tallahassee Project. My oldest daughter used the idea for a class project in her school during "DARE" week. She showed our pictures and spoke about

THE TALLAHASSEE PROJECT

how much it affected everyone when a member of society is warehoused. My family would be interested in learning how to obtain copies of the book once it's publisked.

I thank you for your concern. I would like to be kept posted on what I could do to help out, if possible. I have spoken with a few girls who are interested in learning more about how to involve ourselves and our families to make a much needed reform. I would greatly appreciate any advice you could give.

Sincerely,
Bambi Dawn
P.S. Have a wonderful holiday season!

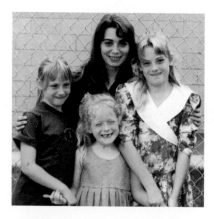

My family is finally able to be together.
Hopefully a lot more families will be put back together soon.
Keep fighting the good fight!

 Bambi

Amber Toni

 Taylor

Deborah Gardner 45268-019 Age 46
10 years 1 month
Conspiracy to possess with intent to distribute cocaine

Mother of one daughter 18 years old. I am a widow, husband died in 1993. Was indicted in 1994 for 1989 case. Went to trial in 1995 and found guilty. Self-surrendered March 1996. First time offender.

Jackie Gates 07467-041 Age 35
5 years Drugs, first offense, non-violent

I have 7 children an one grandbaby an I never been away from my kids. An I was lock up on July 11, 1997 an have not seen my kids since an it hurt. This is my first time ever been in any trouble. My kids are in 3 diffen place. An I waste more money try to contact them when I think I could have been gave house arrest an more years on paper,

40

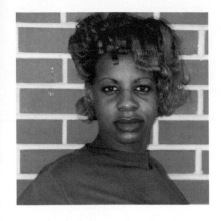

Stephanie George 04023-017 Age 27
Life Conspiracy/ crack cocaine

I am mother of 3 ages 11, 7, 6. They are in counseling behind me not being there. I'm first time offender and innocent of crime. Just guilty of association with child's father. I've even had a write up in Rolling Stone Magazine about how wrong my sentencing was.

Luz Giraldo 09512-069 45 old
14 years Conspiracy/drugs
1re ofensa

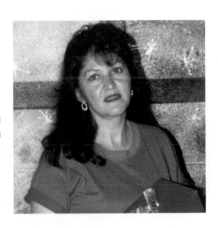

1 ofensa, no violencia, 3 hijos menores, de las cuales mi hija de 10 anos fue violada y abusada sexualente, mi hijo ha pasado muchos trabajos y mi casa es hecho por el F.B.I. Llevo 4 años de de sentencia esto destruyo toda mi familia.

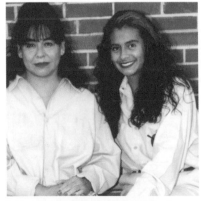

Carmen Eliza Gomez [Mother of Ivonne Gonzalez]
52937-004 Age 45 9 years
Conspiracy to possess cocaine

My name is Carmen Eliza Gomez. I am the mother of Ivonne Gozalez and was caring for her daughter Gina prior to my arrest. My daughter Ivonne has been locked up for over 6 years and has not seen her daughter since Gina was 3 months old.

Six months after my daughter was arrested, a preceeding indictment was issued as a warrant for my arrest. They brought the indictment against me on "hearsay" from someone who wanted their time reduced and said "I sold drugs." I ran for my life in order not to leave the rest of my family in the government's hand. During these last 5 years I tried my best to survive in supporting my son, Manuel Perrico, my other daughter Laurie Moreno (10 years old), and my granddaughter Gina Gisselle. Always hiding out because I knew I was wanted by the feds and knowing they were using the testimony of someone that wanted a reduced sentence. I never thought the day would come, but it did, and I was arrested in July of 1997, and was sentenced to 9 years for Conspiracy to distribute cocaine, even though there were no drugs found in my possession. I was convicted because of what "someone" said 6 years ago, and this "someone" did in fact receive a reduced sentence. The worst part was that the feds were not satisfied with giving

me 9 years, but my son was taken into custody too. He was forced to take a guilty plea so he would not receive so much time -- knowing he was innocent of everything.

My son Manuel Perrico received 57 months. I had to leave my daughter Laurie with a friend's family and my granddaughter Gina with some other family. Due to unfortunate circumstances, my daughter Laurie and my granddaughter Gina have not been in communication or able to talk since this happened. I ask myself every night – What will become of them? I know they feel their family just abandoned them. Gina was taken away from her own mother at the age of 3 months. Now she's been taken away once again from another family member, while my other daughter Laurie was also taken away.

I came to live in Miami, Florida in 1978. I always thought the United States was the land of the Free, the land of opportunity. I thought it was a country that protected its citizens' rights. At one time maybe that was true, but now I ask myself what has happened to our constitutional rights? All I see now in this country is the cruelty and punishment one must pay for someone else to get their time reduced. What will happen to our children and their futures? How are our promises kept to our children if we have to always be on the look-out for our corrupted government?

I am a first-time offender, no drugs were ever found on me or at my house. There were no weapons involved. All I know is that someone received a reduction and now I shall sit here behind these walls and wonder what is happening to our government that it can treat its people the way they do. I always thought the government was the "Good-Guys" and were supposed to keep the laws, not bend them to their own will.

In our Constitutional Rights, Amendment Six says we have the right to confront our accusers. That amendment has been lost for quite a few years now, as so many of us are in prison because of hearsay and someone trying to get their sentence reduced.

I hope it is not too late for someone out there to realize we inmates see the reality in here and live it. Society only sees the mask, and when we come behind these bars they take it off.

I hope and pray that at Christmas my two little ones feel loved and find happiness, because I can't promise them what the future will bring or when I will be able to hold them in my arms again.

Carmen R. Gomez 51950-004 Age 41
57 month Position of Drug
700 g of Heroin

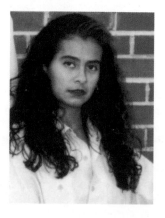

I think the gov. should punish the enformants for the crime the commit and don't take time of they sentence by sentencing someone also. And they should give back the 108 days goodtime. Is about time some of this women go back to they familys.

Ivonne Gonzalez [Daughter of Carmen Eliza Gomez]
45995-004 Age 27
11 years 3 months Conspiracy to distribute cocaine

My name is Ivonne Gonzalez. I was born in Columbia and raised in Miami, Florida. In 1992, I was arrested and sentenced to 11 years and 3 months for conspiracy to distribute cocaine. I was

arrested at 21 years old, and my daughter Giselle was 3 months old. Right now, I am 27 and my daughter is 6. I call her at least once a week and she always asks me the same question, "When are you coming home?"

Those seem to be the only words I can get out of her. It doesn't matter how hard I try to let her know I am here for her and I am her true mother, she does not seem to understand or even care – but how do you explain to a 6 year old child that her mom cannot come home for 11 years?

For my daughter, I am a voice on the phone who checks in once in a while and says the special words: "Hi, how are you?" At the end of the conversation she tells me, "I love you Mommy," but to her I am just a picture, a letter, and a voice.

When the holidays come, tears come too because she feels she has no family to share with. How can she understand Mommy and Daddy can't be with her during the holidays like the rest of the kids around her?

The other day the friend who takes care of her said that Giselle asked, "Can we pretend you are my Mommy and he is my Daddy, and nobody has to know?" When we talk, she is very enthusiastic and after our conversation she hangs up and has no words, she is a different person who just wants to be left alone. My daughter has many questions, but she never asks them. I always wonder who is more scared - her to ask or me to answer?

I am a first-time offender and I am doing time because someone said we sold drugs, though nothing was ever found in my house. I am not totally innocent and I plead guilty to "conspiracy," taking 11 years away from my daughter. I guess when we are young, we live a lot of fantasies and want the world. But is 11 years just punishment for someone who did not kill or have drugs on her?

At one time I had it all, my family, my life, and my Giselle. Now all I have is a phone that connects me to her.

Wanda Growther 05375-030 Age 26
8 years Conspiracy to distribute methamphetamine.

I was living with a wonderful man named Gilbert Sigura. Yes, I did drugs, but I wasn't involved in his "business." It wan't my place to be involved. We traveled across the United States on a vacation and was followed by the feds. My car was broken into by, we assume, the feds because in court they all but admitted there was a tracking device. We were arrested and charged, and Gilbert tried to tell them I was not involved, to let me go or give me a light sentence. But no, the feds wouldn't do that. They told Gilbert to talk and I would get a light sentence. I said NO, so here I am with 8 years. All will be well, and they will never get me again. That's for sure. Thank you!

THE TALLAHASSEE PROJECT

Socorro Guerra 3rd person from the lef standing

Socorro Guerra 19220-004 Age 63
35 years conspiracy in a drug offense
first time offender and non-violent offense

Mother of three girls, of which I haven't seen the two youngest since I get arrested 13 years ago. The government want me to turn in my daughters and because I didn't I got this for me life sentence. Been separated of my family and without any contact with my daughters whatsoever my life is completely destroy, I don't even know how they look or how sound their voices because I am not allowed, otherwise they get arrested. I have a very poor health, a breast surgery, arthritis, two more surgery in my leg and foot.

Hoping and praying every day that more people like all of you show to the outside world our nightmare, and how injustice is our government imposing this long sentences. God bless all of you, thank you in the name of all Inmates in this country.

Rosalba Gutierrez 14390-018 Age 49
24 years and 4 months
Conspiracy on cocaine drug charges

I am a "First Time offender." My offense was non-violent. Mother of two children, one of them retarded. They are living from the welfare because the government took everything from me. I have thyroid problems, hiatal hernia, high cholesterol, etc., etc.

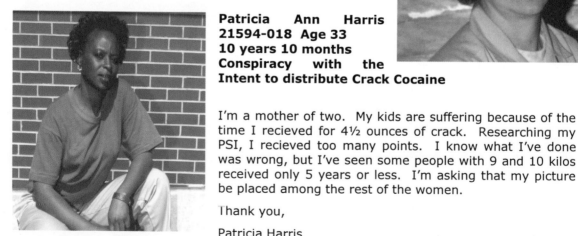

Patricia Ann Harris
21594-018 Age 33
10 years 10 months
Conspiracy with the Intent to distribute Crack Cocaine

I'm a mother of two. My kids are suffering because of the time I recieved for 4½ ounces of crack. Researching my PSI, I recieved too many points. I know what I've done was wrong, but I've seen some people with 9 and 10 kilos received only 5 years or less. I'm asking that my picture be placed among the rest of the women.

Thank you,

Patricia Harris

Robynne Hayes 03474-030 Age 34
11 yrs 4 mos
Conspiracy with the intent to deliver

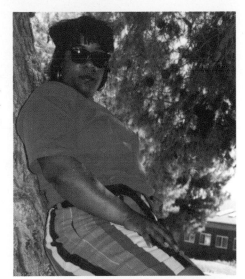

I think the disparity is a big problem and being away from our family and kids are a major problem with our young kids today. Children are left without a Mother or Father and are suffering terribly. We need to do something about the mandatory minimum sentences.

Maria Herrera
37254-004 Age 27
10 years
Conspiracy with intent to distribute cocaine

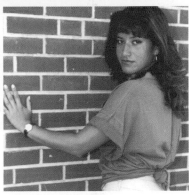

*My name is Maria Eugenia Herrera. I was 29 years old when I was sentenced to 10 years mandatory minimum. Today I am 27 years old, and I decided to write my story for my sister Nancy Montenegro.

Nancy has lupus, which is a fatal disease that doctors give an estimated amount of 10 years to live. My sister has had this disease for 5 years now and has been on dialysis three times a week. She is now divorced, has a son, and lives with our parents because she is unable to do many things.

I have tried the last few years to have my blood test done to see if I am a match with my sister. When I was in FCI-Lexington, KY I was denied the test. The medical department told me I would have to pay for it since I insisted so much. I called my sister Nancy, and told her how the meeting had gone. Nancy contacted her doctor and a kit for testing was sent to Lexington. When the results came back and I found I was compatible, I talked to the head of the medical department about how to get a furlough to be a donor. They explained I would have to pay two escorts and all their expenses. It would be an expensive trip.

I called home with the good news and the next day my sister called the doctor. He said he did not want any responsibility with a prisoner, and the inmate might have some disease.

My sister is in desperate need of a kidney transplant. The waiting list for a kidney transplant is over 200,000 people. I am a potential donor. I have tried every possible way to receive a reduction, but I have not succeeded.

I think I have paid my crime that I committed when I was 20 years old. I am asking for a furlough, not for personal gain but to give my sister a longer life, and I will do the rest of my time after donating my kidney.

THE TALLAHASSEE PROJECT

Karen Hoffman 00644-049 Age 30
10 years Conspiracy to distribute LSD

My name is Karen Hoffman. I am a 30 year old Dead Head from San Francisco, California. On August 16, 1993, I was arrested on federal LSD charges which carried multiple LIFE without parole sentences, for allegedly leading a conspiracy to distribute LSD throughout the United States. My case is a part of the Drug Enforcement Administration's "Operation Looking Glass."

This operation is also known to Dead Heads as "Operation Dead End," as its focus is on us and the Grateful Dead's tours. The DEA has continuously and vehemently denied that this operation has anything to do with the Dead. Yet, my discovery proceedings revealed a DEA Case Initiation Report from Washington which officially placed my case under the "Looking Glass." The cross reference was "G-Fan" (Grateful Dead fan).

Being a faithful fan and follower of the Grateful Dead is in essence my religion, which can be described as a branch of Hinduism and a commitment to a way of life rather than a belief in creeds and dogmas. At the Grateful Dead Shows, we Dead Heads come together in celebration of Life, Spirit, and Being through song and dance. It is a celebration of the spirit that is in each and every one of us, sanctified by the use of LSD.

Operation Looking Glass is a modern-day witch hunt, not unlike in the 17th Century when professional witch hunters would roam the countryside in search of witches. Under it, state and federal agents go undercover exclusively to search for Dead Heads and make arrests. They dress like us and pose as us, which might be reasonably considered entrapment, as they get themselves invited into places where, if their identity were known, they would never have been welcome. Long ago, thousands were put to death for their religious beliefs. Today, there are at least 1,000 Dead Heads serving lengthy federal sentences for their belief in the religious use of LSD.

The government's anti-LSD efforts have been targeted at one particular group, the Dead Heads. The bands logo, "Steal-Your-Face," a symbol of unity amongst Dead Heads, has been declared probable cause for law enforcement officials to stop and search persons and/or vehicles. We are judged by the colors (tie-dyes) of the clothes we wear.

Denied bail after my arrest, I was housed at a facility where we were locked down 23 hours a day. At different intervals, U.S. Marshals would bounce me around from place to place as punishment. Sometimes they would move me twice a week. However, I always wound back up on lock-down status.

The purpose of locking an individual down for 23 hours a day is to break one's spirit and will. Being left alone for long periods of time, in a tomb-like space, can be alienating. I often felt as if I had died and this was the afterlife. In a sense, it was. Life seemingly passed before my eyes. Like a person at death's door, memories of days past would come back to me, people and places I'd known, things I'd done or wished I'd done. Time could be measured by the opening of the cell door. Food came at certain times, medication at others. Time was of no importance, neither was the date or the day of the week.

Operation Looking Glass is used to enforce statutes under the Controlled Substances Act. Under this act, the head of the DEA is empowered to legislate that the religious use of a substance is prohibited. That power was delegated by Congress to the Attorney-General and passed on by the Attorney-General to the DEA Administrator.

Years ago, such laws would have been considered an unconstitutional violation of the separation of powers and of Congress' duty to not delegate its legislative power to others. It would have also been considered an unconstitutional denial of the benefit of doubt, to require a defendant to prove that they possess a drug for religious purposes. In effect, the law establishes a preference for existing, long-standing, status-quo religions over new belief systems.

Throughout the course of all my proceedings, I attempted to fight for Religious Freedom, on the grounds that laws forbidding the religious use of LSD are unconstitutional. Whether or not the government believes as I do is irrelevant. It is not the business of the courts to decide that a religious practice is not a religion under the First Amendment. At the heart of the First Amendment is the notion that an individual should be free to believe as he will. These claims were dismissed in court.

In 1997, the multiple life without parole charges were dismissed by the Sixth Circuit. Still, nothing can take away the trauma of having those sentences hang over my head. For 3½ years, I spent each day not knowing if I would ever set foot outside an institution again.

Ethel Jackson 12768-018 Age 49
Original sentence "Life" –
Reduced to 23 years
Conspiracy First time offender Non-violent offense

Note by Karen Hoffman: Ethel Jackson's entire family was locked up due to the conspiracy charge – her husband, Robert Jackson Sr., her brother Alfonso Jackson, her two sons James Jackson & Robert Jackson Jr., and her daughter April Gordon.

Ethel Jackson writes:

Nearly my whole family is in prison. My daughter, my two sons, my brother, my husband and myself. I'm torn because I never see my immediate family, and my family on the outside is so far away – visits are very few. How can we prove we can be productive citizens when we're facing such lengthy sentences with no one willing to forgive or give us another chance?

THE TALLAHASSEE PROJECT

Robert Jackson Sr. (FCI Leavenworth, Kansas)
12762-018 Age 51
LIFE
Conspiracy
Non-Violent Offense

I know I made a mistake but there was no violence and I have done 7 years in prison. All of this time I have not seen my family. I feel with another chance at life I could do my family better and help raise my grandchildren in the right direction.

Alfonso Jackson (FCI Coleman, Florida) 12767-018 Age 42
40 years Conspiracy Non-Violent
First Time Offender

I was 35 years old when arrested. My whole family was destroyed due to the time I received. Given a 40 year sentence, my wife divorced me and my children are living in different homes. If I had a second chance, I could try and bring my family back together again. I made a mistake but feel that I've paid my debt to society and deserve another chance.

April Gordon (FCI Coleman)
12673-018 Age 31
19½ years originally – reduced to 14 years
Conspiracy
Non-Violent
First Time Offender

I made a mistake, but I want another chance so that I can raise my son. I was 24 years old when I was arrested. No one was hurt in my case except me and my family. These sentences being so long make it hard to hold family ties. I feel 7 years is sufficient in paying my debt to society.

Robert Jackson Jr. (FCI Haute Terre, Indiana) 12764-018 Age 27
Originally sentenced to Life, reduced to 33½ years
Conspiracy Non-Violent
First Time Offender

I was 19 years old when I was convicted. Yes I made a mistake, but doing 33½ years in prison is not helping me to rehabilitate. I have done 7 years and know that I can be a benefit to society and my daughter if given a chance to prove my self.

James Jackson (Oxford, Wisconsin)
12761-018 Age 26 (18 years old when convicted)
30 years
Conspiracy charge Non-Violent offense
First Time Offender

I was 18 years old when I got this charge. I have 2 daughters whom I haven't seen in 7 years due to my incarceration and being placed so far from home. I will be over 40 years old when released. I know I can be rehabilitated and also know it does not take 40 years. I made a mistake but feel I should have another chance!

Gardenia Jackson 47633-004 Age 36
19 years 6 months drug offense
non-violent offense first-time offense

I need to get out to raise my son. I left him motherless at the age of 3. He is destroyed over my leaving him. Yes, I believe I should pay my debt to society, but to be given such a lengthy sentence for a non-violent offense when murderers, rapists, and drunk drivers get off with so much as a slap on the wrist is ridiculous. Mrs. Clinton is always saying that children are the future, yet there are thousands of Americans and other nationalities locked away from their children, and these children are growing up without any guidance. These drug sentences are too long, it does not make sense for non-violent offenders to receive more time than violent.

Yvette James 05152-032 Age 28
70 months
Possession with Intent to Distribute PCP 21 U.S.C. ¶841

I'm a mother of three children, never been married. Mother has legal custody of all three children. I was totally dependent upon my mother for meeting day-to-day necessities. My father was never a part of my life. However I intend to return to Washington D.C. upon my release. Thank you so very much.

THE TALLAHASSEE PROJECT

Crishone Johnson 05809-084 Age 30
20 years: 240 months
Conspiracy to Posses with Intent to Distribute Cocaine Base: 5 counts

I'm a mother of one child. First time of offender felony. First time ever been in prison. I feel that the mandatory sentencing don't fit the crime. I feel of those the conspiracy law should be change.

Alice Jones 29560-004 Age 55
24 years Conspiracy, drug conviction

I am a mother of two, a 19 year old daughter and a 14 year old son. For 25 years I owned and operated my own property rental business, which I began from the ground up. In 1992, I was arrested and subsequently convicted for a drug conspiracy of which I had no part. The government attempted to seize my home and business. A thorough investigation of my business and tax records proved my business to be legitimate. No drugs were even seized from me or my home. My criminal record was based entirely upon people with multiple arrests and lengthy police records, who were attempting to avoid further convictions.

I did not ever imagine such an atrocious nightmare could ever occur in the United States. <u>If this can happen to me, it can happen to anyone</u>.

Beverly Joseph 05198-078 Age 48
20 years Conspiracy to distribute crack cocaine

Missing my family and grandchildren. I have 3 children and 6 grandchildren.

Lorilee Leckness 03778-030 Age 36
17 years Non-violent drug offense

I met my soulmate in high school, we were married shortly afterwards in 1982. In 1998, we were arrested on drug charges. Before we were found guilty, the state took our property. A deputy sheriff had told us we had stepped on some toes when we put money down on it. He said local officials planned on building a new fire department on the site. The attorney hired by our family told us we would be looking at less time had we killed someone. He told us we would be old and grey before we would ever get out of prison. He told us we should leave town and never look back. We're from a small town in Iowa and are extremely close to our families. They had no idea we planned on taking the attorney's "bad" legal advice to leave town. They couldn't believe our laws are so severe.

After we left, our families, even distant relatives, were harassed by local and federal authorities. Their phones were tapped and they were constantly followed. Sheriff's dispatches in the background turned my parents' home into a party line. Federal and local authorities burst in to my parents' home whenever they had company, searched the house and questioned everyone. My family was afraid to do anything but comply, until after numerous raids my mother lost her temper and threatened to sue. The marshalls were evidently waiting for this. One of them pulled a legal form from his jacket and told my mother to sign it and the raids would stop. My parents signed the paper which stated that they would serve five years in federal prison if it was ever found they knew our whereabouts.

My husband and I while on the run gained employment. We had the complete trust of our employer who gave us the keys to his business. If our boss was out of town, we were given the keys to his home and took care of it. We earned his trust, and we never let him down. After our re-arrest, he hired the best attorneys for us and flew half way across the nation for court dates. The prosecutor let us know it was suspicious that anyone would be so good-hearted. He also let us know that the government would be more interested in someone who aids and abets than they would be in us. I guess, meaning that if we made something up on this man we would get little or no time. I found this completely appalling when we had explained our boss was completely innocent.

At sentencing, the judge said he had never received so many letters of community support. He believed we had been drug free since we left home, and that we would never be in trouble again. The judge also commented on the strong marriage bond.

Our family continues to "do time" with us. Dad took photos of the trick-or-treaters this Halloween so I wouldn't miss out. Mom keeps a job to support us in prison. All our family have their way of showing their love. We had our 16th marriage anniversary shortly after sentencing and have not seen each other since. Tallahassee does not allow prison-to-prison phone calls unless there has been a death in the family.

The same sheriff still runs our little Iowa town. Our old home was torn down, just like the deputy sheriff told us the city planned to do before we bought it, and now it is the very fine fire station city officials had envisioned.

THE TALLAHASSEE PROJECT

Mariella Liggio 35197-004 Age 57
22 years Conspiracy to drugs

First time offender. Worked all my life as a real estate agent. At the present moment I am getting my bachelor degree in business. I have done 8 years with perfect discipline. I have attended all types of programs. I consider myself fully rehabilitated. The Drug program – 500 hours intensive course.

Patricia Locklear & **Martin Locklear (FCI Beaver, West Virginia)**
15627-056 **#15622-056**
Age 49 **Age 52**

24 years 4 months **30 years**
Conspiracy drug offense **Conspiracy drug offense**
Non-violent **Non-violent**
First-time offender **First-time offender**

Martin and I have two sons, Marty and Mark ages 29 and 21. We lost everything we owned when we were convicted. We were the only two out of the whole conspiracy who received such lengthy sentences because we did not cooperate (turn someone else in) with the government. So they took everything. The bigger dealers snitched and got their sentences reduced, even though they were big time dealers. And they did not lose their possessions like we did. The system is set up so that people who turn in other people, even though they may be big dealers, receive less time than the smaller people. If you do not have someone to inform on, you are the one that will receive these lengthy prison sentences. And will receive more time than people with violent offenses. There was no violence in our case. These drug laws need to be reassessed. It does not make sense to sentence us drug dealers (where there is no violence involved) to more time than murderers, rapists, etc. Please re-evaluate these laws.

Veronika Londono 40770-004 age not stated
11 years Conspiracy

My name is Veronica Londrano. I was arrested at the age of 19 years old for conspiracy to import 50 kilos of cocaine. I have 5 co-defendants, two of them got arrested and turned my name in, so here I am.

I was sentenced to 11 years of imprisonment and was charged as an organizer in the conspiracy. The prosecution had no evidence. I was arrested by the word of people that got arrested with drugs.

This is my story.

Diana Lopez-Mesa 11992-018 Age 33
12 years Conspiracy of possess cocaine

My name is Diana Lopez-Mesa. I was sentenced to a term of 12 years and I have completed 9 years. During these past years I have tried to reduce my sentence through appeals and I have lost them all.

I have an important reason for wanting my freedom sooner than the judge sentenced me. That reason is my only child. A child that has seen the break-up of his family, the absence of his father, and finally the incarceration of his mother.

My sisters and my mother told me that every week when my son received a card or letter from me, he smelled it first and then he hugged it very tight to his heart and stayed in that position, while, while he was sitting in the living room staring through the window at the sky with his watery eyes, that made everybody sad.

Last Christmas when he was kneeling in front of the nativity that my mother placed for this season at our home. He took baby Jesus doll from the manger and asked Jesus for only one thing.

Melva Lozano 46764-004 Age 49
20 years conspiracy - cocaine

I have 3 chldren and 3 grandchildren. I am a widow. I do not speak English. I was married at 15 years old and never finished grammar school.

THE TALLAHASSEE PROJECT

Alfreda Evette Luxama 09076-018 Age 38
5 years
Possession with the intent to distribute cocaine base

I am a mother of 2 girls. I also have a 5 year old grandson whom I have not seen, but there are three times ….

Mary Elizabeth McBride 09801-042 Age 51
Life Sentence Conspiracy drug offense
Non-violent offense First-time offender

I was 46 years old when I was arrested and I had never been in trouble before. I not use drugs, nor sell them, but I happened to be with someone who had a friend of theirs that had been arrested with drugs. So I was charged with conspiracy. I had no money, no drugs, no bank accounts, did not even own my home but charged with conspiracy you do not have to possess drugs. I have 8 children and 29 grandchildren, and my mother is shifted around from house to house because I am not out there to take care of her. I was innocent but my mistake was being at the wrong place at the wrong time. I feel like I should not have to do a life sentence for this!

Judy McCarroll 08864-424 Age 44
27 years Conspiracy to distribute heroin and conspiracy to laundering

This is the first time I ever been in prison. To me mandatory minimum are destroying our families. The laws need to change. I only have one kidney and have had a problem with it since I been incarcerated . I have learned that if I needed a kidney transplant the government system do not allow that. I deserve another chance in life.

Judy McCarroll sends a photo of her son, Lawence McCarroll, and writes of him:

Lawrence McCarroll 08862-424 Age 24
33 years Conspiracy to distribute heroin

This is my son. First time being in prison. I feel something need to be done about these drug laws. It's destroying so many families, so many children are growing up without their mothers and fathers. And since I have been incarcerated by mother died and I was not allow to attend her funeral. My father is 79 and sick. I'm so far from home.

Louella McCormick 15360-018 Age 43
Life, but recently reduced to 17½ years
Conspiracy of attempt to distribute cocaine base but sentence for crack.

I know what I did was wrong. I have learn a real lesson. I feel after being lock-up for 5 straight years, clear conduct, I should be allowed to go home to my children, whom left at the ages of 17,14, 11, 4, 2, now 23, 20, 17, 10, 8. There was no violence of evidence in my case except peoples testimony against me. I now have 2 grand children. I was the sole provider for my children, my 17 years daughter had to keep them together by the grace of Jesus Christ.

My picture of my five children and 2 grand chldren and future son-in-law

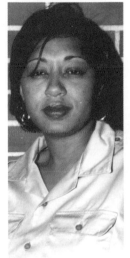

Tonya L. McNeil 16831-054 Age 24
12 Years Conspiracy to Possess With Intent to Distribute, and Distribution of Cocaine Base

I'm a first -time offender. I was taken (incarcerated) from my daughter since she was 5 weeks old. She is now 14 months old. This is my first child and everyday that passes I feel my bond with her slipping. She is the only reason I've made it this far

Reply to an inquiry about her daughter:

How are you? Fine, I do hope. As for myself, I'm okay. Just homesick and missing my daughter.

Anyways, I've enclosed 2 (two) photos. One of my daughter by herself and the other of us together. Please send them back. Pictures are all I have to hold on to, right now.

Oh, my daughter's name is Jenai L. Lee. She is 15 months old (DOB 02.24.97). I've been away from her since she was 5 wks. My father, grandmother (paternal) and daughter's father all pitch together to burden the responsibility of my daughter. She lives in Fayetteville, N.C. Because of my location, I've only seen her once. And, everyday I hurt worse. So, I'm pleading for assistance from you and anyone whom can help.

This conspiracy law has broken up my whole family and the lengthy sentences that are meted out are not fair. Murderers, rapists and child molesters sentences are lower than our non-violent drug offenses. These are bad laws

Sincerely, Tonya & Jenai

Amparo Medina 24537-004 Age 50
17 years 6 months Conspiracy

I am a Columbian woman, living here for 30 years. I have 4 children and 5 grandsons. My husband is in prison also. These sentences are a crushing blow to my family. I have a lot of medical problems. The drug war is a dismal failure.

55

THE TALLAHASSEE PROJECT

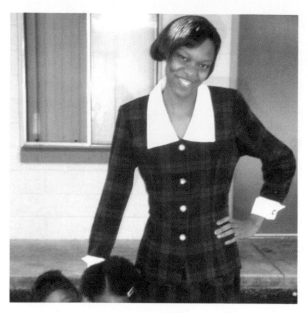

Elainaise Mervil 20982-018 Age 39
20 years
Conspiracy to possess with intent to distribute cocaine base and cocaine hydrochloride

I am a Haitian lady who has left 4 minor children behind to do this mandatory sentence. I have no criminal history. I am a first-time non-violent offender. It seems that the government is tearing families apart and the children are the ones that are really made to suffer for this "War on Drugs." P.O.W.

Letter June 29, 1998:

I fell into the wrong crowd in Orlando, Florida. I have never had any problems with the law and only am now learning to read and write the English language. I am a native of the beautiful country of Haiti. I love America, but I believe that the judicial sytem needs some change and review.

Conspiracy is such an all-encompassing category that if no other charge may be brought forth, one is charged with conspiracy and subjected to the 10-year mandatory minimums which increase rapidly in direct proportion to hearsay evidence whether true or not true. It appears that a person who is found in possession of narcotics will receive less time than a person who was not found in possession of anything, since conspiracy seems like the only viable charge. Conspiracy was originally designed to target "king pins" who are usually sheltered by runners, etc. But what has happened instead is that the king pins are the ones who receive the most favorable deals since they have the most to provide to the government for substantial assistance motions as they possess many many contacts. The "little man" who does not know as much suffers since his assistance is not as valuable; hence, falling victim to harsh treatment under the law by being required to serve a decade-plus in prison.

Many times the information which ends up causing a person to be charged, or having to enter a plea agreement as the consequences would be tremendously worse, is unreliable and "puffed up" in an effort for the informant to receive a better deal. Quite often, the government will tell an informant: "If you give us this, etc., we will give you five years in jail, but if we can say it was 5 kilos instead of 5 grams we'll give you probation." Now, I ask you, which would be the sweeter deal?

Any help you could give me would be greatly appreciated. I went to trial and lost. I received a sentence of 240 months. I had no information to provide the government and was unable to secure a deal so I was subjected to harsh sentencing guidelines.

Being away from my family has been punishment enough. If there was a lesson to be learned, I have learned it. If one wants to know the true picture of my heart, just picture my baby being ripped from my arms as a two-month old infant. I have never seen her since.

P.S. As I told you, I do not speak English and am just learning. When I was first Interviewed, the officicer testified I said certain incriminating evidence. At that time, I did not speak, read, or write English. Now you tell me how such an injustice occurred. Once the complaint states The United States of America vs. You, it is a downhill battle.

Monica Monsalve 44419-004 Age 26
3 years 10 months
Import of heroin

I am divorced and I have a minor child, therefore I am in need of homehold. Somebody made my case to get a reduction in the sentence of another person.

Patricia Moore 82960-020 Age 50
292 months (24 years and 4 months)
Convicted of cocaine, but sentenced under crack
Non-violent offense
First-time drug offender

I have 2 daughters and 1 granddaughter. I am a chronic care patient, suffering from heart, liver, and lung diseases. I've contracted the lung and liver diseases since my incarceration, and have been incarcerated since 1991. I have approximately 14 years left to serve for this first time drug offense. Please help change these drug laws. We are serving more time than violent offenders.

Reyna Morales 04811-112 Age 36
20 years Conspiracy
non-violent offense first-time offender

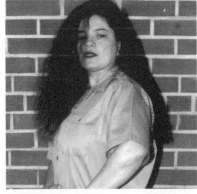

I have two daughters and one son. It's been two years since I've seen them. I am to be deported to my country but must serve 14 years of my sentence. Yes, I made a mistake but I don't think that I should pay twenty years of my life for it. My children need a mother. Conspiracy law breaks up many families and needs to be repealed.

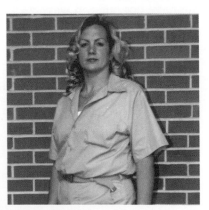

Charlene Morgan
28731-004 Age 36
10 years Conspiracy to possess cocaine
Non-violent first-time offender

Hallo, my name is Charlene Morgan, everybody calls me Char. I'm a 36 year old white female serving a ten year sentence for a drug conspiracy charge. I've served almost half of that already, having been almost two years in county jails. I'm a non-violent, first-time offender. I was indicted a month after being subpoenaed by the defense. I'm actually serving a "guilty-by-association" charge. I

was not given much choice before sentencing. The government promised me 40 years to Life if I did not plead guilty and accept a 10 year mandatory minimum sentence, which I ultimately did.

The government knew then and knows now that I was not involved in my co-defendant's business. I was in no way instrumental in this conspiracy. My co-defendant informed attorneys and investigators that I could somehow help him get out of this, and here I am.

I was working in Key West when all this happened, and had decided to transfer my teaching career of 12 years in Michigan to the Keys. My co-defendant was busted in Tampa whle I was in Key West working.

I remain adamant that I was not assisting him (Michael Derenek) in his operation in any manner: no messages, no sales or other facets of the drug trade. I was however charged with the kilos my co-defendant was busted with. I am being held accountable and punished for my co-defendant's actions.

My family is still recovering from the devastation of all this. I'm incarcerated here in Tallahassee and they live in Michigan, so I don't see anyone ever.

Like I said, I was a teacher, a multicultural, dedicated, enthusiastic, and very active one at that. And with the grace of God I will be again. I will never lose my aspirations and dreams. They may imprison my body, but I refuse to ever let them imprison my mind. Determination and perseverence are mine!

Andrea R. Myers 91921-071 Age 27
262 months Conspiracy to distribute cocaine base "crack".

I'm a 27 year old single mother of a 6 year old son. I'm a non-violent offender and I've done nothing to deserve this time. No drugs at all, just hearsay, and something must change. The time don't fit the crime.

Bessie Oliver 03321-025 Age 44
Life no info

All co-defendants recieve a lesser sentencing and are getting out at this present time. Some have got out and went back.

Brenda Owens 22617-077 Age 44
240 months Drug Offense
First time offender
Non-Violent

I am a single parent of one also a grandmother of one. I am a license cosmetology. I feel that my sentence was very harsh. No drugs was find but I was charged with drugs. This has been very devastating for me and my family. I am very far away from home and I don't get to see my family. It's very hard too keep a family relationship being this far away.

Edith Morales Padilla 44080-004 47 años
97 months
Importacion de heroina 21 U.S.C. 952 (a)

Este tiempo ha sido muy dificil para mi. Especialmente por la muerte de mi hija de 12 años. Y la enfermedad terminal que padece mi otra hija de 23 años, y ml hljo Enrique a ayllon M. De 27 años que està preso en Yazoo City. MS y la separacion de mi esposo, quien me estera en Bogota Colombia.

Evelyn Bozon Pappa
48576-004 Age 36
Life
Conspiracy
Non-violent offense
First time offender

Mother of 4 children. In my case there was no violence and there was no money or drugs found in my possession. The main heavy duty dealers were never arrested, so I am here doing a Life sentence because the government couldn't arrest those people. My kids are having a hard time because I am not at home with them. How do you explain to a child that their mother is doing a Life sentence for drugs where there was no violence? I would like to be deported back to my country. Why should American taxpayers have to pay the cost of housing me for the rest of my life?

THE TALLAHASSEE PROJECT

Patrina Parker 15275-057 Age 26
235 months
Conspiracy to possess with intent to distribute cocaine base

My name is Patrina Parker, I'm 26 years old.

I'm currently incarcerated at FCI Tallahassee, Florida. I am writing because I'm a victim of the Federal Conspiracy laws, which hands down lengthy sentences that don't coincide with the offenses, as you know. I know that drugs have destroyed many families in the communities all of the United States. I'll be the first to admit that my activity and role in selling drugs was wrong, but I did sell drugs from 14 years old to 23 years old to support myself and family due to my family being very poor. I really didn't have a choice. I didn't have a family to help me. My mother sold me to a man to support her habit of using drugs. My boyfriend was 36 years old and I was only 14 years old. He was like a father to me. Someone I never had I turned to him for love, care, attention, which now I am doing a 20 year sentence for conspiracy because of him. If I had a chance to change I would start my life all over to be the mother and father to my son, someone that I never had to keep him from making the same choices that I made. I am being overly punished. My son Dominique, 5 years old, who doesn't have a mother or father because we both are locked up for conspiracy to drugs. He is also being punished for a crime that his mother did. I'm really not being punished. My son is doing a 20 year sentence. The suffering of my son is causing me tremendous stress. My son is not guilty of wrong doing yet he is being punished the most.

I feel that my life would be more productive if I was sentenced to a short term of imprisonment and the remainder of my sentence done in community service. I want to pay my debt to society and put all this behind me and start a new life with my son. I want to assure that he does not make the same mistake, which I have done. He is my child and he is waiting for his mommy to come home. He does not understand that if something isn't done about these Federal guidelines he will be an adult by the time I am released. I have been sitting in prison for 3½ years and I have already learned my lesson. I know what it takes to be a responsible person and a responsible parent. In the United States first time offenders can only be helped by pleading guilty and giving information which at the time they really don't know or can become a threat to their lives. Females also receive longer sentences than males. I urge you to look into this matter and give it your utmost consideration.

Ruth A. Peabody 03440-036 Age 38
5 years 6 months
Conspiracy to sell and distribute cocaine base substance.

I am native American. I believe the US government needs to spend money on education and rehabilitation instead of enabling drug users by building prisons. Prisons, drugs, lock-em-up. It's all about <u>Money</u>. So let's change it.

PRISONERS OF THE WAR ON DRUGS

Cloretha Peak 18114-018 Age 26
Life plus 25 years
Conspiracy to commit carjacking
Conspiracy to distribute cocaine

It's unfair how they are locking us first time offenders up for "conspiracy" and for such long periods of time when we have children at home! No mercy at all!! You can't win in a federal trial. My son is 10 years old at home with my 51 year old mother. Something has to be done. We may not all be saints. But this is ridiculous. I need to be there to steer my child in the direction opposite that which I took. May God show us mercy.

Sonia Estrada Peinado 44449-004 Age 38
3 years 10 months
Conspiracy to possess with intent to distribute heroin

I was sentenced to 46 months and they promised me the drug program and until now they haven't given it to me. I have a 17year old son who is with my older parents. I need to be back in my home as soon as possible.

Glenda Marie Porter 10646-058 Age 34
168 months – 14 years
Conspiracy

I was charged and convicted more than five years after the government claimed I was Involved. One of my co-defendants, James Patrick McGraw, continued to argue his case while in prison. The government dropped the indictment on him for lack of evidence and witnesses. He originally pled guilty. I received the most time of all my co-defendants. The most culpable are free and have gone on with their lives, while I remain incarcerated, shipped all around the country, have not seen my family for almost 3 years. They are elderly and unable to travel due to their health. I have a terminal illness and am afraid of dying all alone in prison, without my family.

Letter June 1, 1998

Yes, I do have a terminal illness, and both of my parents are sick as well. The sentencing judge, Robert Potter, was informed of my illness before sentencing me. He wasn't the least bit concerned whether I died in prison, and that he was possibly giving me a death sentence. It was irrelevant. I got the full 168 months. Most of the real drug dealers are out free walking the streets now that were in my case. There's only a few of us who aren't.

THE TALLAHASSEE PROJECT

Needless to say, we are the ones who didn't cooperate with the government simply because we didn't know any better than to believe we'd have to get found not guilty. Also, we knew nothing to tell them. My other female co-defendant Terry Yvonne Marge, and myself, had not associated with any of the other co-conspirators in over five years and had no knowledge of what had been going on since that time. She got 121 months, and never had a traffic ticket prior to these indictments.

This thing is so crazy and makes no sense at all. I haven't seen anyone in my family or even had a visit since 1995. They've shipped me all around the country, as they are notorious for doing.

Thank you for being concerned and taking the time to respond to me. If there's anything else you'd like to know or any other information you need, please feel free to let me know. Yes, I am scared of dying in prison.

Rosa Pulido 09373-018 Age 39
14 years Conspiracy
Non-Violent First Time Offender

Mother of 3 children. First time offender, non-violent. My husband is also incarcerated. My mother is taking care of my children. We were under investigation for 6 months because they said that my husband was under drugs. There was no possession of money nor drugs. A Government Agent ask my husband to get him some drugs. Since my husband was found with a little bit of drugs I was also convicted.

Wenseslada Reyes 18627-077 Age 45
21 years Conspiracy to distribute

My name is Wenseslada Reyes, but my friends call me Lala. In 1988, at the time of my arrest, I was 35 years old and had three sons: Rigo, John, and Rudy – ages 10, 12, and 18.

The Sentencing Guidelines had just come into effect when I was arrested on a conspiracy charge, and though I was a first-time non-violent drug-offender, I received a 21 year sentence because I took my case to trial. I not only lost my freedom that day, I also lost my family, my home, and everything I owned. The government confiscated my home, leaving my husband and children homeless, along with all of our possessions. Eventually, my husband was arrested on drug charges, and my children were sent to live with different relatives,

After I was sentenced to my 21- year sentence, I was sent to the maximum security prison for women in Marianna, Florida, where I was housed until 2½ years ago when I came to FCI Tallahassee. In all this time, 10 years now, I have not seen my sons, nor any of my family.

I am 45 years old now, and my children have grown into men at the ages of 20, 22, and 28. I have missed out on all those years. After my arrest, my family has not been financially able to come for visits. There has been barely enough money for the necessities in life for my children. They have been raised without their mother or father. I have no pictures of myself with children as there has been no visits with them these last 10 years. I talk to them on the phone when money is available, but that is not very often. My prison job pays me 12 cents an hour, but the money I received from it all goes on my telephone account in order that I may call them as often as I can. I really don't know if I know my kids after all this time, or if they will know me after another 11 years. I always ask myself this question:

"Am I really still their mother after all? After all these years have elapsed, am I a mother in name only? Or am I just the number the government gave me when they separated me from my boys?" Number 18627-077.

Linda R. Rojas 79002-079 Age 44
121 months
Possession With Intent to Distribute more than 1 kilogram of heroin
Importation of more than 1 kilogram of heroin

I was unjustly sentenced. Another arrestee stated falsely against me, but the judge didn't even want to hear it. I have 2 children. A 10 year old daughter who is now left from house to house and needing me. My 27 year old son is also in prison doing a 37½ years to life sentence in New York. This was one of my reasons for acting against the law. Even though I am conscious of my wrong-doing, the years of punishment/rehab do not fit.

June 22 in answer to questions:

My son, Jose R. Ortiz, was sentenced to 37½ years to life for a death and an attempt death. He has been incarcerated since October 1992. It is not a drug case. One of the reasons I chose to make a trip to Panama and return as a mule to the USA, and for which I was sentenced to 121 months, was because I needed the money to pay for his lie detector test which would give him a better chance to an appeal and for a good appeal lawyer.

I chose, due to being in need of money, to travel to Panama as a mule, all expenses paid. I was not aware of the quantity. Only that it would be in liquid form and bottled in 3 bottles – shampoo, conditioner and a body lotion. There was a man in charge in Panama who picked me up at the airport, took me to the hotel, and the night before my returning trip took me to an empty apartment and gave me the bottles and all other instructions. I cleared immigration and then went on to Customs. The agent decided to x-ray the bottles and the drugs were found. From the beginning I collaborated fully with the federal agents, but it didn't help in any way. Three days later, another lady was caught the same way and same airport. My sentence was enhanced to Level 32 because this lady signed a statement stating I was the "head" person.

THE TALLAHASSEE PROJECT

Diane Smith 03442-017 Age 38
180 months Conspiracy with intent to deliver cocaine

I'm the mother of three and the proud grandmother of five beautiful grandkids whom I live deeply. I hope and pray that some day this drug war will end and we can be reunited with our families and love ones. Please keep me in your prayers and may God bless all of you.

Becky Stewart 34290-080 Age 37
18 years
Conspiracy to manufacture and distribute methamphetamine

My name is Rebecca Jean Stewart. I'm from a small town of about 1000 people – Rogers, Texas. If you blink your eyes you will have missed the town. It's about an hour's drive from Austin, which is one of the most beautiful cities in the world and is known for its music. In this city, what comes with the light must come with darkness too. DEA agents. The sole requirement of their job is to trap individuals and set them up to buy larger and larger quantities of chemicals or drugs – to ensure longer and longer sentences when they have entrapped and busted them. Individuals who are not hurting anyone. Oh, maybe themselves by doing what they want with their own bodies and choosing to use prescription drugs or illegal drugs.

My friends are not the violent type. All you hear these days is this person committed this act while they were on some type of drug. The drug I was convicted for is methamphetamine. In all the years that I've taken this drug I've never been violent and neither have my friends. I've always kept my job and helped my grandfather in his old age. I'm not saying drugs are the right way of life. I'm saying that I have a right to my own lifestyle if I don't hurt another person. I don't believe I should be locked away and have a longer prison sentence than, say, a murderer or a rapist. But with our drug laws this is what is happening. Non-violent drug offenders are receiving life sentences plus five years. This means they will never come out of prison.

I ask for your help in changing these laws. I've never raised my hand to hurt another human being, except maybe for the occasional slap to a wayward boyfriend, which I'm sure all us women have experienced. I appeal to the public to educate instead of incarcerate. This warehousing of human beings is not the answer.

Please help to end this War on Drugs. It's a political war where the people lose. Politicians and the DEA make a fortune by seizing people's homes, their money, and all their possessions.

PRISONERS OF THE WAR ON DRUGS

One day you may find yourself in the exact same circumstances and say this cannot be happening to you. Thank you.

Eva St. Germain 10122-058 Age 41
6 years
Conspiracy to possess with intent to distribute powder cocaine

This mandatory sentence was a crushing blow to both me and my family. I have a 22 year old son who was only 16 when I left home. These drug sentences are out of control. I see this "War on Drugs" as the biggest lie since Vietnam.

Billie Marie Taylor 03453-078 Age 28
135 months
Count 1 -- Conspiracy to Manufacture Methamphetamine
Count 2 -- Possession of Listed Chemical
Count 3 -- Possession of a Gun
Count 4 -- Not Having Gun Registered
Age at time of offense: 37, age at time of release: 58, present age: 37.

I was convicted of these four counts in December of 1991. I was a minimal participant but because of the War on Drugs, the Conspiracy Law and the Mandatory Minimums, I was sentenced to 34½ years. When you are charged with conspiracy it takes very little evidence from the courts to get a conviction. As little as someone who is trying to get their sentence reduced to say, "Yes, she knew what was going on." This law has completely changed my life: because of something my boyfriend was doing I'm caught up in a nightmare. I gave him a ride somewhere and ended up in a police procedure called a "Reverse Sting Operation." It did not matter if I knew about what he was doing or not. The way I was charged reads, "Because she was there, under Pinkerton she's guilty of everything her boyfriend has done." (Pinkerton is case law that holds someone guilty because of someone else's action.) The only two people my boyfriend was truly in a conspiracy with was a Houston narcotics police officer and a paid informant. The law reads, It takes two or more people in an agreement to have a conspiracy but it can't be a paid informant or an officer of the law. So they needed someone else to convict him, so I was charged with everything. I was convicted of an agreement that I never entered into, a gun I never used, and charged with 14.96 kilos of methamphetamine that never existed because under the conspiracy law they took the chemical that the police officer bought to sell and converted it into drugs. Even though no methamphetamine was produced from this chemical, government chemists calculated how much it *could* have made and I was charged with this hypothetical amount. They calculated it at 14.96 kilos of methamphetamine and that amount was used to raise my base level to 40, which at this level doles out sentences such as mine of 34½ years all the way up to life.

This law has affected so many low level and minimal participant people and their families. I have two children that are growing up without me. I haven't seen them or my family in

THE TALLAHASSEE PROJECT

almost nine years. This law truly needs to be recognized for what it is. The public does not really realize the sentencing techniques used for sending so many non-violent drug offenders to prison for such lengthy sentences. I'm telling you from first hand experience, it doesn't take much to get 10 years to a LIFE sentence in the federal system. All that is needed in a conspiracy charge is as little as giving someone a ride somewhere or using a friends's phone to make a case under federal law. We are doing decades in here while murderers, child molesters, and other violent crimes are doing the average of three to seven years. I ask you, have you really looked at the way your country's judicial system is being run?

I was 28 years old when I came to prison and with good time (54 good days a year), I'll be 58 years old when I get out. How will I survive then – still off taxpayers? I've done more time for my part in the crime, but I'm still looking at 21 more years. It's like a hole in my soul with a cold winter wind blowing through it.

Billie M. Taylor

Carolyn Taylor 18654-057 Age 25
11 years 3 months Drug conspiracy

I have never had any prior charges. My family and I are now suffering because of hearsay.

Veronika Tillman 39683-004 Age 34
10 years
Pocession with Intent to Distribute Crack Cocaine

They charge me with pocession, they put us my co-defendant and me in the protole car with a tape recorder. They had pruff that I had know knowledge of the drugs in the car prior to them pulling us over. But the State of Florida found me guilty.

Brenda Valencia 39589-004
Age 25
12 years 7 months Conspiracy
Non-violent offense First time offender

I've been incarcerated since I was 19. My father is also in prison (federal). I have not seen him since 1990. Please consider help change these drug laws to make the time fit the crime. Nobody was hurt in my case and I was a minimum participant.

Maria Victoria Velez
03112-112 age not given
7 years 3 months Conspiracy to possess with intention to distribute

I have two daughters, 7 years and 19 years old. They are living with my mother who is in poor health. My family needs me at home. My family is in Columbia (Cali). I have not seen them in four years. My husband is also incarcerated in Miami.

Sheryl L. Waters
11171-058 Age 36
23 years 6 months
Conspiracy to possess with intent to distribute cocaine

Western District of North Carolina. During cross-examination, agent O'Brien admitted that she had no independent knowledge of the accusations she was making against Ms. Waters. The only knowledge she possessed concerning Ms. Waters were statements made by high level drug offenders who were co-defendants in prior proceedings. Agent O'Brien further admtted that no government agent had any personal knowledge of the allegations made against Ms Waters despite a very long and extensive investigation. After an extensive investigation utilizing the combined resources of multiple law enforcement agencies covering months of in-depth narcotics investigative work, no government agent made any statements regarding Ms Waters.

If follow-ups are in process, I would very much like to be contacted (to share my own experience, views, expressions, etc.), for I feel I have been unjustly accused and convicted. I am I dire need of being heard.

Letter Dec 11, 1998:

I wanted to let you know that I'm willing to drum up support for any project that will focus on the overall unfairness of the drug and conspiracy laws. There does not seem to be a slowing down of the number of women coming into the federal system with large amounts of time. The stories all sound the same. Should you or any other organization need support from inside of the prison, I am willing to volunteer my time and knowledge.

Photos: print both? The later one shows effect of last year's government policy tightening dress code for women POWs. First photo taken at time when a POW was allowed own clothes within limits such as not more than 6 shirts, no patterns or designs on them. By the time of the second photo, the new regs had come in. No personal clothes, only what is issued. Women's garb is now all khaki -- "freezing in winter, boiling in summer."

THE TALLAHASSEE PROJECT

Diana Webb
99871-011 Age 30
12½ years methamphetamine

My name is Diana Webb. I am a thirty-year old first-time non-violent drug offender serving 150 months in prison to be followed by 5 years supervised release. Several years ago, I was involved in a friendship with a man who I later found out bought and sold methamphetamine. I was introduced to him by tenants of a rental house he owned, in regard to a real estate transaction.

At first, he seemed charming and we enjoyed a nice friendship. He talked me into signing as a co-applicant on a loan for a rental house on which he subsequently defaulted, ruining my credit. He agreed to fix up the property which also served as his home. Since he had to replace windows and doors, he asked to stay in my apartment during the day while I was at work. Unknown to me, he used my washer and dryer for himself and his friends. He ruined the carpet by disassembling an engine on it. He left cigarette burns, and he ate my food.

I did not want to continue such a friendship, but he refused to leave the premises. He began a cycle of verbal abuse which accelerated to physical blows. I felt less than zero. I thought I was a beautiful aspiring young professional woman. That image of my self dissipated.

Through a support group I found the strength to walk away. For women who have not suffered abuse, it creates a co-dependency and inner shame. You don't want to tell anybody. You long to be loved and out of fear and guilt you stay with the abuser. The friendship lasted only a few months, but the consequences were deeper than anything I could imagine.

During the entire time, he was engaged in a drug-dealing ring. A couple of years after I terminated our friendship, he and two others were indicted for conspiracy to manufacture and distribute methamphetamine. I was questioned by detectives and asked for my cooperation. I had received death threats and did not cooperate. I was included in the indictment.

He cooperated with the government and received a four-year sentence, reduced by one year for participation in a drug treatment program in prison. I was horrified to learn he had molested a child. That charge was swept under the rug, and no action was taken against him, since he had become a government informant.

Under the Federal Sentencing Guidelines I was facing 293 months. A recommendation was made for a downward departure to only 12½ years -- which was thought of as a lucky break – for the abuse documented in medical and police reports and photographs. Since he was a government informant, no action was taken on the abuse cases. In the state of Missouri where I am from, the Crime Victims Compensation Fund pays medical bills related to abuse if criminally prosecuted by the State. Since none of the abuse cases were prosecuted, I had to pay the medical bills out of my own pocket.

I lost my home through forfeiture. I lost my career as an attorney. I lost my job, my license, and 12½ years of my life. I lost the opportunity to have children as I will be too old

on release. I lost precious years with my family. I lost thousands of dollars in legal fees, and I lost happy times with my friends.

When you come to prison, it is very lonely. Everyone forgets about you except your family and your closest friends. The regulations are not only degrading, but promote no rehabilitation or positive role modeling. I was stunned one day when exiting from the dining hall. A hungry inmate had placed several apples in her crocheted bag containing pretty yarn skeins and lovely scarves. A male officer searched the bag. Removal of food from the dining hall is not allowed. On seeing the apples, the officer went outside and threw the bag in a mud puddle, stomping on it, crushing the apples, breaking the crochet hooks and knitting needles, and destroying the bag itself. He returned the ruined bag to the inmate, saying, "There. Now your fruit is applesauce."

Conspiracy was originally meant to catch the "king pin" at the top who frequently escaped prosecution by utilizing underlings. What has occurred is that conspiracy is now an all-encompassing charge under which the man at the top escapes punishment, since he has the most to tell in order to reduce his sentence. Others who may have played a minimal role receive 10 years to life, since they do not have information helpful to the government, or out of fear for their lives dare not reveal information they may have.

With the incentive to fabricate stories due to harsh mandatory sentences for conspiracy, a judicial system based on the Constitution of our Founding Fathers has torn apart families, pitting brother against brother when familiy members are indicted. It has ripped the fibers of the family unit which holds the country together. My father fought in three wars to defend this country. He would turn over in his grave if he could see what this country is doing to its citizens.

Jo Ann Winter 29397-077 Age 51
23 years Conspiracy

There is a great deal of injustice in the judicial system in the US. It is a mistake to take a conspiracy case to trial. An individual becomes a number in the game of justice played by judges, prosecutors, defense lawyers, and co-conspirators.

For four months, beginning in September 1992, I was temporarily employed by three men who formed a partnership and opened a new business that dealt with the manufacture and repain of car hauler trailers. I was the secretary, and my duties included obtaining licenses and permits necessary for doing business and handling receivables and payables that related to said business.

Approximately six months after that brief employment, one of the partners was arrested for a state drug delivery charge. This person was a friend of an was involved in a relationship with my daughter. That relationship had been on-going for several years. Naturally, I was concerned about the situation and was available to assist in any way. I contacted his friends and associates who raised enough money to post bond and obtain counsel. He was arrested again later that year for failure to comply with a judge's order and again I contacted his

friends and associates to request additional funds. During this period of turmoil I gave a pager subscribed in my name to my daughter. I also had a telephone installed in my name for my daughter. The relationship ended, my daughter relocated, but the pager and telephone remained in the possession of the friend. There were numerous subsequent contacts with his friends and associates, then and through the date of his trial for the state charge, which concluded in October of 1995.

One cannot imagine my surprise when I was arrested on November 6, 1996, and charged with "Conspiracy to Possess with Intent to Distribute and Distribution of Methamphetamine and Conspiracy to Commit Money Laundering." I had neither drugs nor money in my possession. I was released immediately after my arrest on a personal recognizance bond. I was no threat to society. I did not obstruct justice. I believed in justice. I went to each court appearance. I proceeded to trial with a court appointed lawyer.

At trial an indicted co-conspirator testifed that I was present at a location when he was there to conduct a drug deal. This was where I worked. I saw no such transaction. He received money from the federal government and time off his sentence from a previous state case for him testimony.

Another unindicted co-conspirator said that someone made a statement to her about me. It wasn't true. She is free. Another unindicted co-conspirator said that she had never seen me, but she saw my car once or twice. She is free. Two other unindicted co-conspirators gave testimony in the trial. They already had sentences of 85 and 79 months from a related case. One will be free in 14 months.

The jury returned a guilty verdict and I was taken into custody and have remained in custody since May 7, 1997. I was sentenced on July 30, 1997, to 276 months (23 years). Eight of the alleged co-conspirators received sentences that were much less than mine. I don't even know five of these people. The newspaper reported that I would serve "only" 228 months.

Since being transferred to prison, I have been separated from my family. I am 900 miles from home. At age 51, I am serving a Life sentence.

I no longer believe in justice.

Shirley Tucker Womble 09330-017 Age 50
25 years Conspiracy to Possess with Intent to Distribute Marijuana

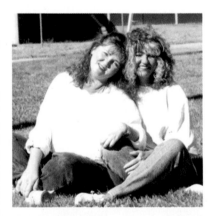

I am a wife and mother of two children, my husband is incarcerated on this charge also. He received a 32 year sentence, he is a non-violent first [time] offender. There was a forfeiture of our home and business, even though the same jury that found us guilty found our business not guilty the courts still sold our business. The government put forfeitures against my son and daughter's home and they did not have money to hire attorneys. My children were never indicted, but they lost their homes because we had co-signed on their mortgages. I have since been told by the AUSA that prosecuted us that I was indicted with the purpose of getting my husband to cooperate in order to keep me out of prison.

Photo captions: (1) Shirley Womble and daughter (2) Clarence Womble and son. Message on reverse reads: Is this better than wheelchair?

Clarence Womble writes:

I am a non-violent first offender. I went to jury trial and was found guilty. The government put forfeitures on our home and business even though it was proven that they were not purchased with drug proceeds. The government still sold everything. The government used hearsay and circumstantial evidence at our trial. I feel that the sentence that was given to me as a non-violent is unjust 32 years for a person at my age is a life sentence.

Note from Karen Hoffman about the Wombles: They are home owners you'd like to have for neighbours. They are very good people.

Margaret Woodard	Pamela Woodard	Alva Groves
#15231-056	15229-056	15230-056
58 years old	27 years old	77
30 years	17½ years	25 years
Conspiracy		
Non-violent Offense		

Note by Karen Hoffman (principle author): Alva Grove's entire family was locked up due to the conspiracy charge – her daughter, Margaret Woodard; her granddaughter, Pamela Woodard; and her three sons, Ricky Lee Groves, Fontelle Groves, and William Groves.

Margaret Woodard writes:

This conspiracy law has affected my whole family. In the picture is my mother and daughter. Along with us are 3 more brothers with sentences of 12, 23 years and Life. Our attorney said if we would take plea bargains we wouldn't receive such long sentences. But we still have lengthy sentences as above. None of us were in possession of money or drugs. A government agent came to our town on the pretext of selling food stamps. The agent wanted money for the food stamps or drugs. The agent solicited us to bring her drugs and even though at the time of us arrest there were no drugs or money – they charged us with conspiracy and gave us these lengthy sentences.

Margaret Woodard has made out a Tallahassee Project United Nations form for her son, Ricky Lee Groves, and sends this with a photograph of him. She has enclosed a second photograph of Fontelle Groves (age 33, FCI Butner, North Carolina, sentenced to 12 years) and William Groves (age 52, also imprisoned at FCI Butner, sentenced to 23 years for the same offense.)

Ricky Lee Groves (FCI Beaver, W. Virginia)
19069-016 41 years
NATURAL LIFE SENTENCE Conspiracy Non-Violent Offense

I have a daughter and a son whom I haven't seen in 4 years. I know I made a mistake by messing with drugs but I don't believe I should have to spend the rest of my life I prison for it when people with violent offenses receive far less time than us drug offenders.

THE WOODARD FAMILY

Of the women responsible for bringing this work to a conclusion, Maria Herrera and Becky Stewart remain incarcerated in FCI Tallahassee.

Maria Herrera has a release date of 2001, too late to prevent her sister Nancy's death from renal failure. Describing the frustration of her wish to donate a kidney to her sister, Maria wrote in a letter dated June 1, 1998:

> To be honest I am losing faith because no one has answered any of my letters. I have appealed, written letters to my judges and prosecutors but still no positive results. Now I am waiting to see if the Director of the B.O.P. will grant my departure or at least give me permission to be a donor.
>
> As you can see, anyway I try I am stuck here with my hands folded. I pray every night that something good will come through soon because I know my sister cannot hold on till I come home, her condition is too weak.

Her last letter, undated, reads:

> UPDATE: The above was written a couple of years ago for preparation of this book. Since that time the following details have developed pertaining to my sister.
>
> On January 13, 2000, Thursday, I received my response from Roger C. Adams, Pardon Attorney, U.S. Department of Justice stating:
>
> PLEASE ADVISE MS. HERRERA THAT HER APPLICATION FOR CLEMENCY HAS BEEN CAREFULLY CONSIDERED IN THIS DEPARTMENT AND THE WHITE HOUSE, AND THAT THE DECISION HAS BEEN REACHED THAT FAVORABLE ACTION IS NOT WARRANTED. HER APPLICATION HAS THEREFORE BEEN DENIED. AS A MATTER OF WELL ESTABLISHED POLICY, WE DO NOT DISCLOSE THE REASONS FOR THIS DECISION IN A CLEMENCY MATTER, AND UNDER THE CONSTITUTION, THERE IS NO APPEAL FROM THIS DECISION.
>
> The next day much to my disbelief I was granted a BEDSIDE VISIT with my sister Nancy at the hospital.
>
> My family and priest had called the institution to alert them that my sister only had 3 days to live the max. After all these years, I finally was able to see my sister. It was a true blessing because it was her last wish to see me and mine as well to say GOOD BYE giving her my last hug.
>
> I was brought back to the institution and my sister died two days later.
>
> I would like to ask one question. JUST WHAT IS THE BUREAU OF PRISONS' DEFINITION OF COMPASSIONATE RELEASE?

Perhaps Mr. Adams will answer that question for you, Maria. If it is some consolation, know that your help in introducing Spanish speaking prisoners to the Project is deeply appreciated.

Becky Stewart took on the Tallahassee Project when it was no more than the germ of an idea. Her ready sense of humor and dedication to the cause of justice have been a source of inspiration ever since. Without Becky's determination to overcome all obstacles, this book would not have seen the light of day. That a quarter of all women imprisoned in FCI Tallahassee on drug charges took part in the Project shows the depth of her commitment.

Becky's release date is 2012.

Asked by telephone on November 3, 2000 if she feared retaliation by Bureau officials, Becky replied:

"I am not afraid. They can't do anything to me."

"Suppose they ship you to another prison, in the desert somewhere or a boot camp. Are you sure it's all right you going public like this? You don't think there's a danger of them acting weird?"

"Nah. They can't do anything to me. This work is not for profit. No one's making any money. And those two women, that reporter from the Spanish station got in to see them finally, after you told her to call the ACLU lawyer. Nothing happened to them."

"OK. Remember to send that photo, the one you want in the book when it comes out."

"Oh you can be sure of that. And good luck on your trip to the publisher."

Thanks, Becky. You've been a sweetheart.

Karen Hoffman, architect of this work from the beginning, was shipped to FMC Carswell, the prison hospital for women in Fort Worth Texas, where she has been confined since September, 1999. Her release date is 2002

Last spoken with on December 2, 2000, Karen reported that her condition is unstable. She has applied for compassionate release but does not expect her application will be granted. Two patients applied for compassionate release before her, but died before the paperwork was processed.

Karen, we salute your bravery and acknowledge your profound achievement. If one person deserves the credit for this work, that person is you. You made the dream come true.

Of the women who took part in the Project, some remain in the Tallahassee prison and some are confined in other prisons in the United States. By now, perhaps two have finished their sentences and moved to halfway houses.

Grateful acknowledgement is made to each of you for your help. Some of you parted with precious photographs to make the Project a reality . Some of you signed up to have your photo taken – at five bucks a throw on a salary of 12 cents an hour. You put your feelings on the line in the hope that the people of America will rethink their support of the War on Drugs.

Originally, the purpose of the Project was to place a document in the hands of the UN Secretary-General and call for a response at the highest level. That things did not work out as planned is just as well. Publication of this book brings the reality behind America's War on Drugs to everyone. People across America will ask the fundamental question: Is the Drug War really necessary? Is suffering on the scale depicted in this work justifiable on moral or indeed any grounds? What is the War on Drugs supposed to accomplish? Who is victimized by whom? To what end? Who profits? Who gains?

These questions will test the fiber of us all if the purpose of The Tallahassee Project is achieved.

APPENDICES

DRUG WAR SENTENCING IS UNJUST SENTENCING

Many of the women in this book accuse the courts of levying disproportionately long sentences for drug law violations.

Is this true? Disproportionate to what?

Below is a list of criminal offenses taken from the Federal Sentencing Guidelines Manual and the corresponding sentences a judge is required to impose. (The sentences are required for first or second time offenders; sentence length increases for habitual offenders.)

TABLE 1
EXTRACTS FROM FEDERAL SENTENCING GUIDELINES

Offense	Sentence
Murder 1st Degree	Life in prison
Murder 2nd Degree	135 – 168 months/ 11 to 14 years
Manslaughter	57 – 71 months/ 5 to 6 years
Involuntary Manslaughter	6 - 12 months/ ½ to 1 year
Kidnapping	51 – 63 months/ 4 to 5 years
Robbery (Bank, Carjacking, etc.)	33 – 41 months/ 3 to 3½ years
Rape	70 – 87 months/ 6 to 7 years
Criminal Sexual Abuse of Minor	18 to 24 months/ 1½ to 2 years
Sexual Abuse of a Ward	4 –10 months/ less than 1 year
Blackmail	4 –10 months/ less than 1 year
Counterfeiting	4 –10 months/ less than 1 year
Public Officials Receiving a Bribe	6 – 12 months/ ½ a year or less

Compare these figures with the length of sentence served by women prisoners of the War on Drugs in FCI Tallahassee.

Note that 7 out of the 100 are doing Life:

> Theresa Brown
> Diane DeMar (Life + 5 years)
> Stephanie George
> Mary Elizabeth McBride
> Bessie M. Oliver
> Evelyn Bozon Pappa
> Cloretha Peak (Life + 25 years)

Factor in a further 3 prisoners who were sentenced to Life in prison but had their terms reduced on appeal:

> De-Ann Coffman (Life, reduced to 85 years)
> Ethel Jackson (Life, reduced to 23 years)
> Louella McCormick (Life, reduced to 17½ years)

The result? An astounding 10 percent of the women who participated in the Tallahassee Project were sentenced to Life imprisonment at the time of initial sentencing.

There is no reason to suppose that women who participated in the Project were self-selected on the basis of sentence length. Anecdotal reports from federal prisons other than FCI Tallahassee suggest a similar figure throughout the Drug War prisoner population. (The proportion of Life sentences imposed on men Drug War prisoners is certainly no less.)

Remember that in the federal system a Life sentence means exactly that. A Life sentence means you stay in prison until you die – from disease contracted in prison or from old age.

Next, consider the length of the sentences imposed on Tallahassee Project women *not* currently condemned to spend the rest of their natural life in prison. Including the terms currently being served by De-Ann Coffman, Ethel Jackson, and Louella McCormick, the total number of years to which the non-Life women have been sentenced is 1575. Divide by 93, and the average length of sentence that results is just under 17 years.

Assign an arbitrary figure of 50 years for the length of a Life sentence, and the total number of years recorded rises to 1725. The average sentence length for the Tallahassee Project population then rises to 17¼ years.

If you find this figure disproportionate to the length of sentences in Table 1 for all but the offense of Murder 1st Degree, you are committed to the following argument: Drug War sentencing is disproportionate. Disproportionate sentencing is unjust. Therefore, Drug War sentencing is unjust sentencing.

APPENDIX 2

U.N. TO DISCUSS DRUG POLICY; PROTESTS PLANNED

(STATEMENT ISSUED BY THE DRUG REFORM COORDINATION NETWORK, JAN. 1998)

On June 8, 1998, the United Nations will open its first-ever General Assembly Special Session on Narcotics. The session was originally proposed by the Mexican government as an international forum on the effectiveness of the global drug war. But the agenda has been rewritten to narrow discussion to ways in which the current policy can be strengthened, based on the Single Convention Treaty.

The centerpiece of the session will be the official unveiling of the United Nations' new anti-narcotics initiative, to be presented by Pino Arlacchi, director of the new U.N. Office of Drug Control and Crime Prevention (www.undcp.org) based in Austria. [For more on Arlacchi and the U.N.'s anti-drug efforts in Afghanistan, see p. 15.]

In response, concerned individuals from around the world have come together to form the "Global Coalition for Alternatives to the Drug War" and have declared June 6 and 7 "Global Days Against the Drug War." During those days, protests in different locations around the world will draw attention to the lack of consideration given to alternatives. The weekend will culminate with a protest in New York City on Monday, June 8.

APPENDIX 3

THE DISAPPEARANCE OF APPELLATE RIGHTS

Since Congress enacted the Anti-Terrorism and Death Penalty Act in 1996, most of us are limited to filing an appeal within a year of our sentencing date. The Act was in retaliation to the Oklahoma bombing and the World Trade Center bombing. Its purpose was to shorten the time between a death sentence and the execution of a terrorist or mass murderer. But the new Act not only deters convicted terrorists and murderers from filing an appeal, but has a detrimental effect on Drug War defendants. In many cases, years have been added to a sentence because of miscalculations on the part of courts, wrongful application of enhancements, or Constitutional violations, and there is now no effective remedy in our hands.

The Anti-Terrorism and Death Penalty Act, known as the AEDPA, restricts the appeals process by limiting the time for finding mistakes and filing appeals to the one year anniversary of sentencing. After sentencing, it takes an average of two months for a defendant to be transferred from a county jail or one of the privately owned holding centers (America's newest booming business) to the processing center in Oklahoma, and from there to the designated federal prison. This leaves approximately ten months for an appeal to be filed before the one year time limit is up.

We are unfamiliar with the whole justice system when we arrive at prison, not understanding how our sentences ended up so lengthy. We know there must be something wrong that can be corrected on appeal. After all, we live in America, the country built on impartial justice.

We locate the prison library; we talk with other inmates on how to become enough of an attorney to do an appeal in the remaining ten months before it's too late. (Like that is possible, right?). We find that our attorneys could have done a lot more to help, as we discover errors. We learn the Guideline System and the many kinds of enhancements used to lengthen an already lengthy sentence.

There may be an enhancement for one's role in a "conspiracy" that's open to dispute. There may be an enhancement if the defendant had a firearm – in a conspiracy case there are multiple defendants and if just one of those other people had a weapon, every defendant is eligible for added years because that one person is said to own a gun. Such things we try to learn, together with the statutes and clerical rules one must follow when writing an appeal.

This is only half the work. We must find cases to support "the issue." What would take an attorney less than five minutes to find on a computer takes us hours of research to find. Everything, of course, is in "legal language" and difficult to understand. Finally, it comes down to typing the appeal, if you are lucky enough to find one of the twelve typewriters available for approximately 1,000 inmates. We will need multiple copies from an ancient copy machine at a cost of over $6.00 for every fifty copies. Even mailing an appeal can be a hair-raising experience.

In the end, for the few of us who make the one year deadline, the common response is "denied." In a lot of cases there is no reason given on the issues, just the word "denied." We believed in a fair and impartial system. We believed that the appeals courts would rectify the wrongs. For each of us lucky enough to get an appeal in, every denial is a heartbreak, not just for us, but for our children, our siblings, and all of our family.

In a media report from 1999, a federal appellate judge from the Eighth Circuit spoke out at a college in Des Moines, Iowa. His name was Judge Arnold, and his Eighth Circuit area hears appeals from Arkansas, Iowa, Minnesota, Nebraska, North and South Dakota, and Missouri. This brave judge spoke out on the "rubberstamping" of the denial of our appeals. He stated that he had recently participated in a court session with other appellate judges in which over fifty appeals were decided in a mere two hours. That is two minutes, fifteen seconds per appeal. (Probably just enough time to look at the name on the appeal and make sure it's no one of importance to the judges before stamping it "denied").

It is no wonder we get no response on the issues in appeals; no one had time to read them. Judge Arnold's description of his feelings was quoted: "I

feel dirty. It was a betrayal of judicial ethics. It makes me feel dirty." His statement may have been a warning to us.

What if one of us cannot do our own appeal, or cannot hire an attorney to do one? The AEDPA (Anti-Terrorism Act) takes care of that. If we are past the one year time limit, we're pretty much out of the ball game. There is no getting past the rules that this act lays on us (we who are not terrorists or murderers). As one judge put it, the chances are "almost nil that one could get in through the safety hatch," the smallest of doors left open by Congress. Either there must be a "New Constitutional Rule of Law" or an appeal must be based on "newly discovered evidence" for one to pass through the gate of the AEDPA after the one year deadline has elapsed. Old issues, anything left from court error to Constitutional violations, no longer matter. Let's pretend one of us is skilled enough to grab the judge's attention on an appellant argument as to why the issue should be heard. We would be up against many of top Justice Department attorneys, because the Justice Department sends out update booklets to every prosecutor telling the best way to defeat an appeal. The DOJ will give examples: "If the appellant tries to use this case, you can knock him out with that case," and so forth.

One has to wonder what is behind this picture. What makes once honorable men participate in the evils of the Drug War? After the Nuremberg trials of the Nazi regime, the U.S. government told the Germans that they should have followed their conscience instead of their government when it did wrong. Where is the American government leading us all — We the People — with these new practices?

-- Lorilee Leckless

APPENDIX 4

HEARSAY AND CONSPIRACY

Conspiracy is the most common charge against Drug War offenders and it is literally unbeatable in court. Instead of the prosecutor "proving" us guilty, we must prove ourselves innocent against hearsay. How else could a person with no drugs found anywhere around them end up in prison on a drug charge? A drug charge with no drugs at all for evidence is commonly called a "dry conspiracy." Defendants in "dry conspiracies" will be linked to drug amounts by hearsay and assigned a Guideline level by the prosecutor.

With the conspiracy law, whatever a person says they "think" we had, is what we are punished for, not what we had. We are not punished on a Guideline level corresponding to the amount in possession, but rather on a Guideline level based on what another person says they "think" we had. Then, if the prosecutor is not satisfied with the amount the person says we had, he can ask how long they "think" we were doing drugs. However long the person claims (let's use the example of five years), the prosecutor multiplies the amount of drugs we are "thought" to have sold by the five years we are "thought" to have been doing drugs, to reach an exaggerated level. When the prosecutor arrives at an amount he is happy with, he presents it to the judge for sentencing. The judge must dole out a prison term within the Guideline level the prosecutor puts before him. Whatever his conscience and experience tell him the correct sentence for a particular individual would be, he is bound by the iron rule of the prosecutor's calculation.

Astonishingly, the normal origin of hearsay is someone the prosecutor is threatening with a lengthy prison sentence should he not "cooperate" with the

government. Not only can the prosecutor threaten, he can bribe with cash and cars. By far the most powerful tool of the prosecutor, however, is the threat of years of prison and forced labor and the confiscation of most or all personal belongings for the failure to cooperate.

The authority given to the prosecutor by Congress exceeds the authority a judge has at every stage of the judicial system. Congress, in fact, could have eliminated the "black robed honorable" and his bench from the courtroom in most drug cases, and the result would be the same.

-- Lorilee Leckless

APPENDIX 5
THE DEFENSE ATTORNEY: THE AMERICAN CONSTITUTIONAL RIGHT

There is a cute book called *Gideon's Trumpet* by Anthony Lewis. It's about a man named Clarence Gideon who was wrongfully imprisoned because he could not afford an attorney and was not able to properly defend himself, being a man of little legal knowledge. In 1961 he wrote a simple letter to the Honorable Justices and they accepted his letter and announced they would hear his issue as to whether the Constitution guarantees a defense attorney in every case. Gideon's trumpet (his letter) made national news and in the end the Justices decided that, yes, our Constitution does guarantee that a lay person is not capable of presenting his own legal defense. The Justices decided that every state will appoint an attorney if one cannot be afforded, to present an effective defense for every accused person. All prisoners unjustly incarcerated at that time were able to get back into court with an attorney to present an effective defense. Gideon was found innocent and after his "illegal" incarceration was set free.

The court-appointed defense attorney in the new American justice system, where does he come in? Sad to say, the attorney comes in where and when he pleases. Most of us are incarcerated on arrest and thus are prevented from gathering evidence and finding witnesses on our own behalf. Few court-appointed defense attorneys answer our phone calls from jail. In most cases, we will only see the attorney a couple of times at jail visits, each time averaging ten to fifteen minutes. This is hardly enough time to explain the law we are charged with violating and the Guideline system of punishment, let alone for the attorney to become familiar with our case.

In the end, we sign plea agreements and are processed through a system we do not understand. Witnesses are not questioned and evidence on our behalf is not gathered. Today a common attorney phrase is "Cops lie, and the courts are on their side." We sign plea agreements because the attorney tells us that if we do not, we will be too old for a normal life on release from prison, if we even get a release date. Many of us were lied to on legal issues so that we would sign a plea agreement. To confess guilt to things we are not guilty of is hard. But based on the minute percentage of trial wins in drug cases, and the years added to a sentence for exercising the right to a trial, signing a plea is the lesser of two evils.

Maybe defense attorneys are so frustrated by laws that are unfairly "stacked" against us Drug War defendants that they do not see a reason to defend us. Be that as it may, today we have court-appointed defense attorneys as the Supreme Court required in Gideon's case, but often a defense is not presented.

-- Lorilee Leckless

10 THINGS YOU SHOULD KNOW ABOUT PRISONS IN THE U.S.

1. There are approximately *2 million* people in US prisons and jails today, and *5.7 million* people under state supervision

2. The incarceration rate in the United States is 725 for every 100,000 — the highest in the world. One in every 130 people will serve time at some point in their lives.

3. One of *three* African American men in the US will serve time in prison in their lifetimes.

4. The number of women serving time in state and federal prisons has increased 92% in the last 10 years.

5. The US currently cages more people of color per capita than any other nation.

6. It costs *more* to send a person to prison for a year than to Harvard University for a year.

7. The prison system is not filled with violent and dangerous people; the majority of people are being sent to prison for drug charges and acts which involve *no violence whatsoever*.

8. Private corporations such as Eddie Bauer and Lexus employ prison slave labor. Prisoners are forbidden by law to unionize or strike; they are not protected by minimum wage laws for the Fair Labor Standards Act; they cannot voice complaints or even refuse to work without receiving *severe* retaliation.

9. Conditions in US prisons have been repeatedly condemned by groups such as Amnesty International and Human Rights Watch for violating the United Nations *Standard Minimum Rules for the Treatment of Prisoners.*

10. Healthcare for prisoners is practically nonexistent. It is common practice for prisoners to be denied medical examinations and treatments.

Contrary to what the government and mass media lead you to believe, sources such as the *Uniform Crime Report* and *Sourcebook of Criminal Justice Statistics* confirm that there has been no increase in the crime rate. Yet the imprisonment rate has more than tripled and expenses for criminal "justice" have increased six-fold.

Facts compiled by the Prison Activist Resource Center in cooperation with Oberlin Action Against Prisons. PARC,, P.O. Box 339, Berkeley, CA, 94801, www.prisonactivist.org; OAAP, P.O. Box 285, Oberlin, OH, 44074.

MORE DRUG WAR FACTS

Compiled by Kendra E. Wright and Paul M. Lewin for The Common Sense Drug Policy Foundation www.drugsense.org/factbook/

PRISON

- As of 1996, there were 5.5 million adults under some form of correctional supervision — prison, jail, probation, or parole. This translates into 1 of every 35 adults.

 Source: Bureau of Justice Statistics, *Nation's Probation and Parole Population Reached Almost 3.9 Million Last Year,* (Press Release), Washington D.C.: U.S. Department of Justice (1997, August 14).

- As of June 1997, there were 1.7 million inmates nationally: 1.2 million in state and federal prisons and one-half million in local jails.

 Source: Cilliard, D.K. & Beck, A.J., *Prison and Jail Inmates of Midyear 1997,* Washington D.C.: Bureau of Justice Statistics, U.S. Department of Justice (January, 1998).

- In 1985, our incarceration rate was 313 per 100,000 population. Now [1998] it is 645 per 100,000, which is three to ten times higher than rates of the other modern democratic societies. The largest single factor contributing to this imprisonment wave is an eight-fold rise in drug arrests. In 1980, when illicit drug use was peaking, there were about 50,000 men and women in prison for violating drug laws. In 1997, there were about 400,000 drug prisoners.

 Source: Reinarman, C. & Levine, H.G., "Casualties of War," *San Jose Mercury News,* (letter), March 1, 1998), Sec. C, p. 1.

- According to the department of Justice, studies of recidivism report that "the amount of time inmates serve in prison does not increase or decrease the likelihood of recidivism, whether recidivism is measured as parole revocation, re-arrest, reconviction, or return to prison."

 Source*: An Analysis of Non-Violent Drug Offenders with Minimal Criminal Histories,* Washington D.C.: U.S. Department of Justice (February, 1994), p.41.

- The United States operates the biggest prison system on the planet.

 Source*: Currie, E., *Crime and Punishment in America,* New York, NY: Metropolitan Books, Henry Holt and Company, Inc. (1998) p. 3.

- The overall U.S. incarceration rate is six times that of its nearest Western competitors.

 Source*: Currie, E., *Crime and Punishment in America,* New York, NY: Metropolitan Books, Henry Holt and Company, Inc. (1998) p. 61

- If one compares 1996 to 1984, the crime index is 13 points higher. This dramatic increase occurred during an era of mandatory minimum sentencing and "three strikes you're out."

 Source*: Federal Bureau of Investigation, *Uniform Crime Reports 1996,* Washington D.C.: U.S. Government Printing Office (1997), p. 62, Table 1.

- Over 80% of the increase in the federal prison population from 1985 to 1995 was due to drug convictions

 Source: U.S. Department of Justice, Bureau of Statistics, *Prisoners in 1996,* Washington, D.C.: U.S. Government Printing Office (1997).

- From 1984 to 1996, California built 21 new prisons, and only one new university.

 Source: Ambrosio, T. and Schiraldi, V., "Trends in State Spending, 1987-1995," *Executive Summary – February 1997,* Washington D.C.: The Justice Policy Institute (1997).

RACE ISSUES

- Nationwide, only 11% of the nation's drug users are black, however blacks constitute almost 37% of those arrested for drug violations, over 42% of those in federal prisons for drug violations, and almost 60% of those in state prisons for drug felonies.

 Sources: Substance Abuse and Mental Health Services Administration, *National Household Survey on Drug Abuse: Population Estimates, 1996,* Rockville, MD: Substance Abuse and Mental Health Administration (1997), p. 19, Table 2D; Bureau of Justice Statistics, *Sourcebook of Criminal Justice Statistics 1996,* Washington, D.C.: U.S. Government Printing Office (1997), p. 382, Table 4.10, p. 533, Table 6.36; Bureau of Justice Statistics, *Prisoners in 1996,* Washington D.C.: U.S. Government Printing Office, (1997), p. 10, Table 13.

- One in three black men between the ages of 20 and 29 years old is under correctional supervision or control.

 Source: Mauer, M. & Huling, T., *Young Black Americans and the Criminal Justice System: Five Years Later,* Washington D.C.: The Sentencing Project (1995).

- At current levels of incarceration, newborn black males in this country have a greater than 1 in 4 chance of going to prison during their lifetimes, while Latin-American males have a 1 in 6 chance, and white males have a 1 in 23 chance of serving time.

 Source: Bonczar, T.P. & Beck, A.J., *Lifetime Likelihood of Going to State or Federal Prison,* Washington, D.C.: Bureau of Justice Statistics, U.S. Department of Justice (1997, March).

- In 1995, the incarceration rate for white and Latin-American women combined was 68 per 100,000. For black women it was 456 per 100,000.

 Source: Bureau of Criminal Statistics, *Sourcebook of Criminal Justice Statistics 1996,* Washington DC: U.S. Government Printing Office (1997), p. 510, Table 6.12.

- Fifty-four percent (54%) of blacks convicted of drug offenses get sentenced to prison versus 34% of whites convicted at the same offenses. Forty-four percent (44%) of blacks get prison sentences for possession versus 29% of whites; 60 % of blacks are sentenced to prison for trafficking while 37% of whites are sentenced to prison for the same crime.

 Source: Bureau of Justice Statistics, *Sourcebook of Criminal Justice Statistics,* Washington DC: Bureau of Justice Statistics (1996), p. 501, Table 5.50.

- In 1986, before mandatory minimums for crack offenses became effective, the average federal drug offense sentence for blacks was 11% higher than for whites. Four years later following the implementation of harsher drug sentencing laws, the average federal drug offense sentence was 49% higher for blacks.

 Source: Meierhoefer, B.S., The General Effect of Mandatory Minimum Prison Terms: A Longitudinal Study of Federal Sentences Imposed, Washington, D.C.: Federal Judicial Center (1992), p. 20.

- Regardless of similar or equal levels of illicit drug use during pregnancy, black women are 10 times more likely than white women to be reported to child welfare agencies for pre-natal drug use.

 Sources: Neuspiel, D.R., "Racism and Prenatal Addiction," Ethnicity and Disease, 6: 47-55 (1996); Chasnoff & Barrett, M.E., "The Prevalence of Illicity-Drug or Alcohol Use during Pregnancy and Discrepancies in Mandatory Reporting in Pinellas County, Florida," New England Journal of Medicine, 322: 1202 – 1206 (1990).

- The Hispanic community has been disproportionately affected by HIV/AIDS. Although Hispanic persons only represent 12% of the U.S. population, they represent 17.8% of all AIDS cases

 Source: National Coalition of Hispanic Health and Human Services Organizations. HIV/AIDS: The Impact on Minorities. Washington, DC: National Coalition of Hispanic Health and Human Services Organizations, Figure 1, pg. 11 (1998).

APPENDIX 8
WOMEN IN PRISON IN THE US: THE FACTS

1. There are nearly 900,000 women currently 900,000 women under correctional supervision in the US. Approximately 15% are confined to prisons and jails (*BJS Sourcebook*)

2. There are now 46 women on Death Row nationwide. Almost half had a history of abuse and are there for the murder of an abusive spouse or love, most often in defense of their lives and the lives of their children.

3. Self-defense is involved approximately 7 times more frequently when women kill men than when men kill women. According to the *Sourcebook for Criminal Justice Statistics*, 55% of all women will be raped and/or physically assaulted in their lives. **Over one half of all women murdered are killed by a spouse or partner.**

4. In some surveys, 90% of battered women who reported assault to the police actually signed complaints, **but fewer than 1% of the cases were ever prosecuted.**

5. Women are the fastest growing sector of the entire prison population. Since 1980, the female inmate population nationwide has increased more than **500%** (*Bureau of Statistics, 1998*). But this is not due to increases in more serious criminal behavior. In 1979, women were sent to prison for **nonviolent crimes** roughly 49% of the time. In 1986, women were sent to prison for **nonviolent crimes** roughly 59% of the time. Currently women are sent to prison for **nonviolent crimes** nearly 80% of the time (*Bureau of Prisons population report*).

6. 80% of imprisoned women have children and of those women, 70% are single mothers. Prior to their imprisonment, 84.7% of female prisoners (as compared to 46.6% of male prisoners) had custody of their children.

7. **Women prisoners spend on average 17 hours a day in their cell with 1 hour outside for exercise.** Male prisoners spend on average 15 hours a day in their cell with one-and-a-half hours outside.

8. Mothers in prison are less likely to be visited by their children than are fathers because women are shipped to other counties or remote areas of a state more often than men, and because children of incarcerated parents are often moved for foster care.

9. A survey conducted in 38 states revealed that 58% of the prisons or jails serve exactly the same diet to pregnant prisoners as to others and in most cases **do not meet the minimum recommended allowances for pregnancy.**

10. In early 1998, 2,200, or 3.5%, of all female state prisoners were HIV-positive (*US Bureau of Justice*). Incarcerated HIV infected women have no access to experimental drug trials, compassionate use and new drug protocols.

Facts compiled by the Prison Activist Resource Center PARC, P.O. Box 339, Berkeley, CA, 94801, www.prisonactivist.org;

APPENDIX 9
RESPONSIBLE USE AND HELP FOR THE ADDICTED

In the short term, increasing the availability of drug treatment would be the most important and effective policy initiative. Drug treatment is not perfect – many addicts relapse. But relapse rates are comparable to the rates of those who fail to change their behavior in dealing with chronic diseases such as diabetes or hypertension. Over time, many addicts are successful in quitting. A leading California study found treatment to be seven times as cost effective as imprisonment. A RAND Corporation analysis found that cocaine consumption could be reduced by 1 per cent by spending $783 million in source countries, $366 million on international interdiction, $246 million on domestic enforcement, or just $34 million on treatment.

About two million addicts were treated in 1996, but 3.3 million were unable to get treatment. The percentage of prisoners getting drug treatment in prison has decreased during the 1990s. For the poor and uninsured, publicly funded treatment is almost nonexistent.

Evaluations have found current youth drug-prevention-through-abstinence programs almost totally ineffective. Given that 50 per cent of U.S. youth end up experimenting with drugs, a safety-first message needs to be adopted instead of focussing on total abstinence. Promoting responsible use is the current policy with alcohol, e.g. suggesting the use of designated drivers. Promoting responsible-use to drugs would be honest, acknowledging that most youths stop with drug experimentation and do not become addicts. Often programs that have nothing to do with drugs directly, such as Big Brother/Big Sister, have dramatic effects in reducing youth drug use.

Drug abuse by women has been increasing in the U.S., while male drug abuse has been declining. More research regarding female drug abusers, as well as treatment programs for women, is vitally needed. In addition, discriminatory policies toward women should be stopped. Women should not

be forced to give up their children to enter drug treatment programs. Regrettably, the State of New York had to be sued before it would provide drug treatment to pregnant addicts....

An enlightened drug policy would recogize that drug use and drug abuse are two different matters, and such a policy would focus on reducing drug abuse. America has a genius for regulation, but that genius has not yet been applied to the drug problem.

Eric Sterling, Criminal Justice Policy Foundation
Foreign Policy in Focus, Vol. 4, No. 31. November 1999 (excerpted)

APPENDIX 10

WHAT IS THE PRISON INDUSTRIAL COMPLEX

The "Prison Industrial Complex" is a term that refers to:

- The exponential expansion of prisons and jails, with rising numbers of men and women prisoners from communities of color;

- The increasingly symbiotic relationship between private corporations and the prison industry (construction, maintenance, goods and services) — a relationship in which private corporations feed the punishment industry and the punishment industry yields enormous profits for private corporations;

- The reliance of many communities on prisons and jails for short-term economic vitality, particularly in the aftermath of corporate migration to impoverished countries in Latin America, the Caribbean, and South East Asia'

- The increasing political influence of prison guards, prison officials and conservative penologists;

- The collaboration of politicians and the corporate controlled dominant media in the wholesale criminalization of all communities of color (and particularly youth of color) and in the representation of prisons as a catch-all solution to social problems (problems created by capitalism in the first place).

 --Adapted from an address given by Angela Davis for Critical Resistance: Beyond the Prison Industrial Complex

Of the country's 1.8 million prisoners, more than 11,000 are in the prisons of the 18 private prison corporations. The two largest are Corrections Corporation of America and Wackenhut.

Corrections Corporation of America (CCA)

(81 prisons, more than 71,000 prisoners) Operates prisons in Arizona, Colorado, Florida, Georgia, Idaho, Indiana, Kansas, Kentucky, Louisiana, Minnesota, Mississippi, Montana, Nevada, New Jersey, New Mexico, North Carolina, Ohio, Oklahoma, Tennessee, Texas, Virginia, Puerto Rico, Australia, UK.

Wackenhut Corrections

(52 prisons, more than 26,000 prisoners) Operates prisons in Arkansas, California, Colorado, Florida, Louisiana, Michigan, Mississippi, New Mexico, Oklahoma, Pennsylvania, Texas, Virginia, Puerto Rico, Australia, UK.

SLAVERY WITH A NEW NAME

"Slavery is being practiced by the system under the color of law. Slavery 400 years ago, slavery today, it's the same thing, but with a new name. They're making millions and millions of dollars enslaving blacks, poor whites, and others— people who don't even know why they're being railroaded."
— Political Prisoner Ruchell Magee

"Neither slavery nor involuntary servitude, *except as punishment for crime* whereof the party shall have been duly convicted, shall exist within the United States, or any place subject to their jurisdiction."
— 13th Amendment to the U.S. Constitution

The 13th Amendment to the US Constitution, usually thought to have abolished slavery, actually codified it.

Most prisoners do work of some sort, whether it be for the prison they're incarcerated in, a state or federal agency, or a private company. Most of these jobs are low skill, such as cleaning the prison, or making uniforms or furniture for a state agency or Unicor (the federal agency that supplies furniture and other materials to the federal government and a handful of private companies).

While relieving the daily monotony of prison life, most prison jobs are not teaching skills that will help prisoners once they are released. The majority of this work has no demand outside. Almost all these low wage jobs have been moved to Latin America, the Caribbean, and South East Asia.

Low Wages

While wages vary from state to state, California prisoners receive "minimum wage" ($5.75), 80% of which is taken by the state:

> 20% to victims rights organizations
> 20% into a state restitution fund
> 20% to anti-drug campaigns
> 20% to an inmate "trust" fund
> **Leaving 20% to the prisoner**

So the actual wage of a California prisoner is a high $1.15 an hour. With everything from toothpaste to phone calls to medical treatment grossly inflated, prisoners actually get to keep little of what's left. Many prisoners make under $.20 per hour, and some don't get paid at all.

Unsafe, Unfair, Inhumane

The conditions for working prisoners are among the worst in the industrialized world. There are no benefits, no vacation, no decent health care, no safety standards, and prisoners are not allowed to form a union. Severe repression and longer sentences result form a refusal to work. Prisoners are beaten, put in solitary confinement, or both. There is no oversight of prison labor conditions, and no accountability, so prison officials have no incentive to provide safe working conditions or treat prisoners humanely.

Enter Private Companies

Illegal for many years, private companies employing prisoners directly was again made legal in the mid-70s. This arrangement is attractive for corporations because they pay about the same or less as they would in Mexico, but they use the Made in USA label. Prisons and corporations are very

reluctant to release details, but we do know that in 1993 about 1,000 prisoners were working for private companies and by 1998 that number had risen to 2,500 prisoners working for 135 companies. Currently many prisons are reorganizing themselves in order to accommodate private companies. If we don't stop it, this number is going to skyrocket.

This creates a very dangerous dynamic. Large corporations, with a lot of help from the media and politicians, have a strong interest in creating a larger and larger prison population so they can have a larger cheap labor pool. This results in increased sentences, and the increasing criminalization of large blocks of society (mostly low income people and people of color).

All this is not to say that prisoners should not work. Prisoners should have the same right to work as people on the outside. They however need to have safe, meaningful work, decent pay, and the right to organize or unionize.

Some of the Companies That Profit from Exploitation of Prison Labor:

TWA	Motorola
McDonalds	Toys R Us
Texas Instruments	AT&T
Dell	Revlon
Kaiser Steel	Eddie Bauer
Spring	Lexus
Microsoft	Boeing
Victoria's Secret	Honeywell
Pierre Cardin	Nordstrom
MCI	Jostens
IBM	

Source: Prison Activist Resource Center PARC, P.O. Box 339, Berkeley, CA, 94801, www.prisonactivist.org;

APPENDIX 11
UPDATE DECEMBER, 2000

Of the women who helped to organize the Tallahassee Project, Maria Herrera (page 45) faces deportation to Columbia.

A letter written from Tallahassee in June, 1998 describes the frustration of her wish to donate a kidney to save her sister Nancy's life.

> I am losing faith because no one has answered any of my letters. I have appealed, written letters to my judges and prosecutors but still no positive results. Now I am waiting to see if the Director of the B.O.P. will grant my departure or at least give me permission to be a donor.
>
> As you can see, anyway I try I am stuck here with my hands folded. I pray every night that something good will come through soon because I know my sister cannot hold on till I come home, her condition is too weak.

Her most recent letter, undated, reads:

> The above was written a couple of years ago for preparation of this book.

On January 13, 2000, Thursday, I received my response from Roger C. Adams, Pardon Attorney, U.S. Department of Justice, stating:

PLEASE ADVISE MS. HERRERA THAT HER APPLICATION FOR CLEMENCY HAS BEEN CAREFULLY CONSIDERED IN THIS DEPARTMENT AND THE WHITE HOUSE, AND THAT THE DECISION HAS BEEN REACHED THAT FAVORABLE ACTION IS NOT WARRANTED. HER APPLICATION HAS THEREFORE BEEN DENIED. AS A MATTER OF WELL ESTABLISHED POLICY, WE DO NOT DISCLOSE THE REASONS FOR THIS DECISION IN A CLEMENCY MATTER, AND UNDER THE CONSTITUTION, THERE IS NO APPEAL FROM THIS DECISION.

The next day much to my disbelief I was granted a bedside visit with my sister Nancy at the hospital.

My family and priest had called the institution to alert them that my sister only had 3 days to live the max. After all these years, I finally was able to see my sister. It was a true blessing because it was her last wish to see me, and mine as well to say goodbye giving her my last hug.

I was brought back to the institution and my sister died two days later.

I would like to ask one question. Just what is the Bureau of Prisons' definition of compassionate release?

A letter from a friend of Maria's dated December 28 states:

Maria's release date was December 13. She was picked up from the prison by INS (Immigration and Naturalization Service). She is now in an immigration detention center in Miami fighting deportation. Even though her family is from Miami, they are deporting Maria unless she can convince them at her Immigration Hearing to let her stay in the United States. They are sending her to Columbia even though she has spent the majority of her life in the U.S. and all her family is here.

Like many Latins who face deportation when their prison terms are finished, Maria has no one when the plane lands in Columbia. They say Maria translated Spanish for a man who wanted to buy drugs. They call that a conspiracy.

* * *

Becky Stewart (page 64) took the Tallahassee Project to heart when it was no more than the germ of an idea. Becky, your respect for justice and dedication to the welfare of others have been a source of inspiration ever since. That one in four of women imprisoned on drug charges joined the Project shows the depth of your commitment. Without your leadership, this book would not have taken shape.

At present, Becky remains incarcerated in FCI Tallahassee. In a letter written on December 28 in Tallahassee she reminisces:

I can remember when all of this first started. Karen was like a locomotive in trying to get the women united in a cause to gather their stories, photos, etc. She enlisted my help and I joined her. We ran around meeting with the women, went back to get their photos, went to the library and typed them. We were like tape recorders stuck on rewind. Maria came along and typed a few stories for us. Then at the tail end, Lorilee's help was enlisted....

Did I tell you that my Mom and ex-boyfriend came to see me the day after Thanksgiving and visited for 2 weeks? It was great. I hadn't seen my Mom in nearly six years, and I hadn't seen my ex since 1989. He wants to get married, but I don't want to in prison. I still have 10 more years to do.

I heard Clinton pardoned Dorothy Gaines and Kemba Smith. It seems the only people who get pardoned are the ones that get their cases publicized. I don't know what you think about that. I know what I think.

* * *

Karen Hoffman (page 46), architect of this work from the beginning, was shipped to FMC Carswell, the prison hospital for women in Fort Worth Texas, where she has been confined since the fall of 1999. Her release date is 2002.

Last heard from on December 2, Karen reported that her condition is deteriorating. Confined to a wheelchair, she has applied for compassionate release but does not expect her application will be granted. Two prisoners applied for compassionate release before her, but died before the paperwork was processed.

Karen, we salute your bravery and acknowledge your profound achievement. If one person deserves credit for this work, that person is you. You made the dream come true.

* * *

Many of the women who contributed to the Project are confined in federal prisons other than FCI Tallahassee. Friendships, mainstay of prison life, were broken as prisoners were dispersed in retaliation for the food strike in July, 1998. A small number have finished their sentences and moved to halfway houses, coping with the indignities of "supervised release."

Grateful acknowledgement is made to each for your help. Some of you parted with family photographs to make the Project a reality . Some paid for photos to be taken – on an income of 12 cents an hour. You put your feelings on the line in the hope that America will learn the truth, turn against the War on Drugs, and call for the release of unjustly imprisoned people.

* * *

The fate of many Tallahassee women, Drug War and non-Drug War prisoners alike, hangs in the balance. In a new development, the Bureau of Prisons has entered into a 12 month contract with the state of Virginia to dispose of overflow at federal women's prisons.

A report from Tallahassee on December 20 tells of shipments of Tallahassee prisoners to Fluvanna Correctional Institute, a facility run by the state prison authority in Troy, Virginia.

To date, 120 women have been taken from Tallahassee, to join at least 150 from other federal prisons.

The most recent shipment from Tallahassee, on December 17, included Lorilee Leckness, a supporter of the Tallahassee Project. Friends of Lorilee are worried. Other women have been heard from, but not Lorilee.

"Overcrowding" is the official explanation. The report from Tallahassee describes waves of incoming prisoners, the great majority prisoners of the War on Drugs, to take the place of departing prisoners as fast as they leave.

Word filtering back from Fluvanna Correctional Institute tells of brutal conditions facing new arrivals. Staff tell those awaiting shipment to submit to shoulder length haircuts and cutting of fingernails, "or else."

The new arrival at Fluvanna Correctional Institute faces permanent lockdown. She will leave the lockdown unit only to go straight to and from meals. Inside the unit, there is no provision for education or recreation.

Treated as a state prisoner, she is stripped of her federal registration number and given a Virginia state prison number instead. Mail addressed with a federal registration number may or may not get through.

Telephone privileges are severely limited. Since the success of the law suit four years ago claiming exploitation by phone companies, federal prisoners make phone calls at a cost of $2.25 for 15 minutes, paid by the prisoner. At Fluvanna Correctional Institute, phone access is limited to a collect call once a week, for which the receiving party pays $11 for 10 minutes.

The law library at Fluvanna Correctional Institute stocks a quantity of state law books, but only seven federal law books. Nominally a federal prisoner but virtually a state prisoner, Lorilee Leckness will not be able to proceed with the federal case she was building in the law library at Tallahassee.

Fluvanna Correctional Institute has no work for its prisoners except "landscaping" for a few. There is consequently no way for a woman to profit from her labor. Price gouging at the prison commissary is nothing new, but here is liable to cause extreme hardship. A 5 inch TV set can be purchased from the commissary for $189 – if funds can be obtained to make the purchase.

Visits are limited to one hour once a week.

The report on which this information is based speaks of ominous developments in Bureau of Prisons thinking. Federal money will not be spent on building prisons to accommodate new prisoners. Federal prisoners will be transferred to low-bidding state authorities, swelling state prison populations at small cost to the federal government. If after 12 months the outcome of the trial at Fluvanna Correctional Institute is satisfactory, the contract will be renewed and the program of transferring federal prisoners to state prisons expanded.

Tallahassee women are afraid. No one knows whose turn will be next. There is widespread complaint of the injustice of a federal prisoner "doing federal time in state prison."

Members of the House of Representatives from Florida were contacted and asked to intervene, but none showed interest.

* * *

Originally, the purpose of the Project was to place a document in the hands of the UN in the hope of a high-level response. That things did not work out as planned is fortunate. Publication of this book brings the reality behind America's War on Drugs to everyone. It raises fundamental questions: Is cruelty on the scale depicted in this work justified? What is the War on Drugs supposed to accomplish? Who is victimized by whom? To what end? Who profits? Who gains?

These questions will test the fiber of us all, if the purpose of The Tallahassee Project is fulfilled.

SPECIAL ACKNOWLEDGMENT

All of us would like to express our thanks and extensive gratitude to Dr. John Beresford of the Committee on Unjust Sentencing for his spirited dedication in seeing this project through.

It was John's encouragement that brought many of us forward for the first time. His immeasurable compassion is overwhelming. He continues to offer us hope, when we feel none, and shall forever remain a shining ray of light in our dark world.